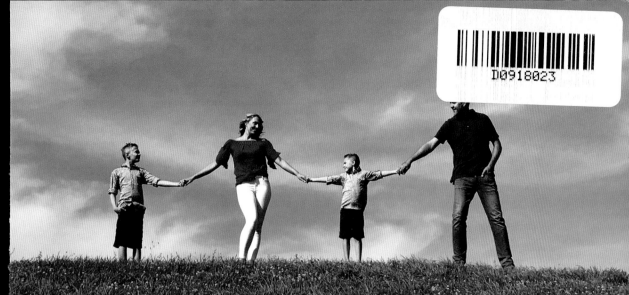

Phone Photography for Everybody
Family Portrait Techniques
for iPhone, Android & All Smartphones

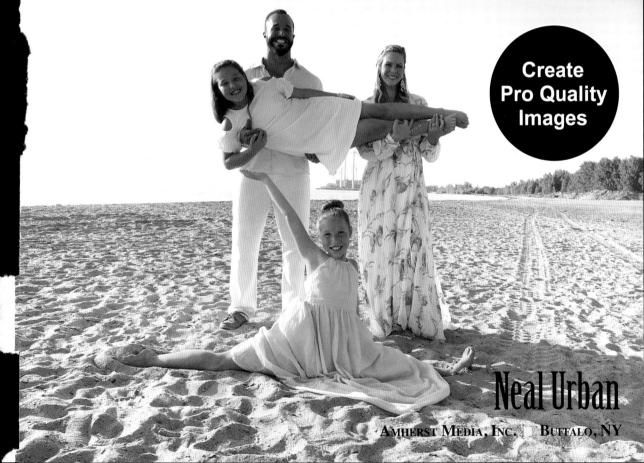

Create
Pro Quality
Images

Neal Urban

AMHERST MEDIA, INC. BUFFALO, NY

Published by:
Amherst Media, Inc.
PO BOX 538
Buffalo, NY 14213
www.AmherstMedia.com

Publisher: Craig Alesse
Associate Publisher: Katie Kiss
Senior Editor/Production Manager: Barbara A. Lynch-Johnt
Senior Contributing Editor: Michelle Perkins
Editor: Beth Alesse
Acquisitions Editor: Harvey Goldstein
Editorial Assistance from: Carey A. Miller, Roy Bakos, Jen Sexton-Riley, Rebecca Rudell
Business Manager: Sarah Loder
Marketing Associate: Tonya Flickinger

ISBN-13: 978-1-68203-436-1
Library of Congress Control Number: 2020984902
Printed in the United States of America
10 9 8 7 6 5 4 3 2 1

AUTHOR YOUR PHONE PHOTOGRAPHY BOOK WITH AMHERST MEDIA

Are you an accomplished phone photographer? Publish your print book with Amherst Media and share your images worldwide. Our experienced team makes it easy and rewarding for each book sold and at no cost to you. Email submissions: craigalesse@gmail.com.

www.facebook.com/AmherstMediaInc
www.youtube.com/AmherstMedia
www.twitter.com/AmherstMedia
www.instagram.com/amherstmediaphotobooks

Contents

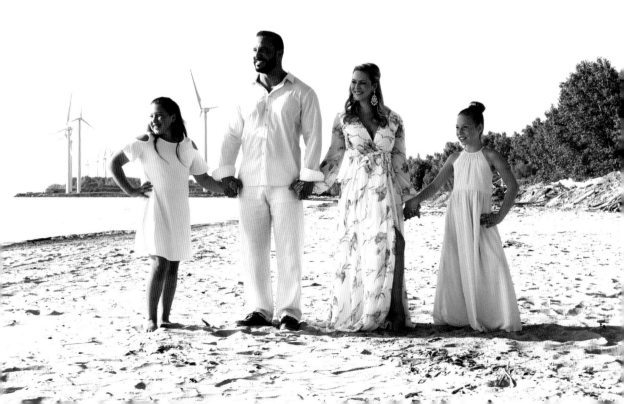

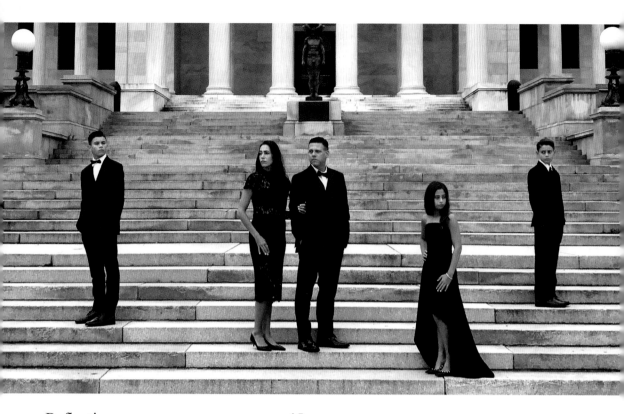

About the Author

Neal and Danielle Urban are husband-and-wife wedding photographers based in Buffalo, NY, who also capture destination weddings around the world.

Neal is a self-taught, third-generation photographer who discovered his passion for creating images after picking up his late grandfather's WWII-era camera.

In 2016, Neal earned the elite title of Master Photographer by WPPI (Wedding and Portrait Photographers International). He is also the author of numerous books, including: *The Art of Engagement Portraits: Lighting, Posing and Postproduction for Breathtaking Photography; Dream Weddings: Create Fresh and Stylish Photography;* and *Master Techniques for Wedding Photography: Lighting, Composition, Editorial Style, Postproduction, More.*

Together, Neal and Danielle have won some of the most prestigious awards that photographers can receive.

Introduction

Everyone loves to capture photos of their family, but not everyone has a traditional, bulky digital camera, or wants to carry one with them. I've written this book to help the everyday mobile photographer create better images of their family with just their phone. This book will teach readers how to make the most of natural light and pose both small and large groups. It will also teach readers how to take images at various times of the day. A photographer's

dream lighting usually exists close to sunset, but good photographs can be taken at any time of day, once you understand how to work with what Mother Nature—and architecture—presents. Other essential topics will be covered, too, including color to black & white conversions, basic editing, and backing up your images.

You'll find four families' portraits in these pages, with each one photographed in a different location. As you

"Your mobile phone is the perfect tool to use to create family portraits when you're on the go."

study the portraits and techniques, you'll gain confidence and the knowledge you need to create pro quality images in any location you have in mind.

One of the main questions asked by hobbyists who are just getting into photography is what their first camera should be. I always say a camera phone is the best tool to have because your phone is always with you. They can use their phones to practice some basic techniques and then graduate to a digital camera with interchangeable lenses. Of course, when you learn to effectively use your iPhone or Android camera, you may decide that it is the only camera you need.

Let's start with the basics.

Camera Setup

The question I am most often asked is: "I want to get into photography. What camera should I buy?" My answer: "Do you have a mobile phone? If so, then that's all you need to get started." With the sophisticated cameras available in today's smartphones, you have a rugged and compact camera, and you can start to understand lighting, exposure, composition, and posing. You can also dabble into some postproduction, but for this book, I kept things simple. I did not use any third-party apps for postproduction. I personally shoot with an iPhone, and I used only the native Camera app to slightly tweak some of my images. I also did not use any external lighting, bounce boards, or reflectors. You don't need to go out and purchase any photography equipment. All you need is your phone.

For this book, I worked with the iPhone 7+. Several versions of newer iPhones were released, including the iPhoneX, Xr, and iPhone 11 Pro (the phone with multiple lenses). I wanted this book to be helpful for everyone, and not just the people who had the newest phone model. This is all about the basics—and it's perfect for iPhone and Android users alike.

For the file sizes and settings, I kept everything basic, so all you have to do is open your camera and shoot the same way I did. If you're really getting into photography and want to do any editing or want to print some of your photos at some point down the line, it's best to shoot in High Efficiency mode. In this mode, your camera will create smaller files, while still producing high-resolution files (1080 pixels). Using the High Efficiency setting allows you to store more photos in your camera roll, and you will still have high-res files. This will come in handy should you want to create wall art or do some creative cropping.

If you are shooting with an Android phone, simply do a quick Google search for "resolution settings" or "file sizes" to figure out how to optimize your

"The next thing I'd like you to do is to turn on the Grid feature."

particular phone's image capture. The feature names and options may differ, but you will be able to select file size and resolution settings that allow for high performance.

The next thing I'd like you to do is to turn on the Grid feature. When you do, you will see a tic-tac-toe shaped grid over your screen. You'll use this grid to create eye-catching compositions using the Rule of Thirds. We'll delve into that topic later in this book.

If you are using an iPhone, simply go to the Settings menu, select Camera, and then tap on the Grid option so that the button turns green. All Android functions differ based on the make and model of the phone you are using, so if you need to use Google to find out how to access the Grid function on your particular phone, please do.

The iPhone's Portrait mode is an option if you want a beautiful blurry background behind your subjects—as professional photographers like to achieve using a telephoto lens on a DSLR camera. Unfortunately, the iPhone camera does not always do a good job at creating the blur; sometimes, when you photograph someone, the camera might blur a part of their clothing. Also, if you are photographing a group of people in Portrait mode, one person may look blurry.

I mentioned the importance of creating high-resolution images earlier in this chapter. You may be tempted to zoom in closer to your subjects using your camera's digital zoom, but that can hinder your image quality. It's a better idea to "zoom in" with your feet. Just get closer. If you have a telephoto lens (x2) on your iPhone 11 Pro or a later phone, though, feel free to use it for your close-up portraits.

As I mentioned earlier, I did not use any artificial light to create the portraits in this book. You won't want to use your camera's little flash, either, so make sure to deactivate the auto flash feature.

Now that we've taken care of the basics of our camera setup, it's time to get started and learn about the nuts and bolts of creating family portraits.

Suburban Casual

We did this session early in the afternoon, under partly cloudy skies.

Getting a Correct Exposure

The term "exposure" refers to the amount of light in the scene recorded by the camera to create an image. A "correct" exposure is one in which an average scene has a full range of tones—from white to black, and all of the tones between. An overexposed image will have pure-white areas that lack detail. You'll want to avoid that. An underexposed image will have black shadows without detail. You will want to avoid that, too. Your phone will try to determine the correct exposure for the scene you are photographing, but it isn't always accurate. If the scene is too dark, the flash may turn on, or the camera may automatically choose a slow shutter speed. This can result in blur if the subject, or anything else in the scene, moves. Blur can also occur if you, the photographer, do not have a steady hand. When working in low-light situations, try to use a tripod, or use a nearby item such as a chair or table to keep the phone steady. If the scene is too light, the

top and bottom.
These setup shots show how the family was positioned for these two shots.

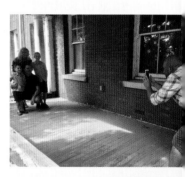

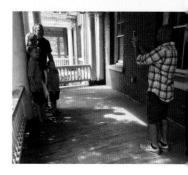

> ## *"When working in low-light situations, try to use a tripod, or brace your phone on a chair or chair or table to keep the camera steady."*

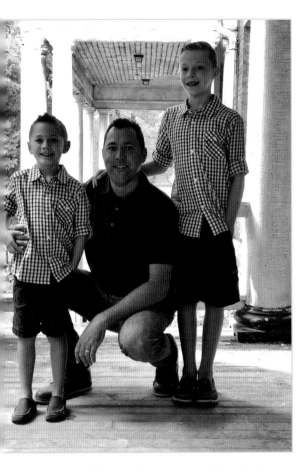
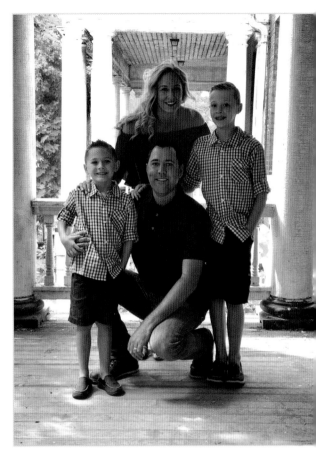

camera will restrict some of the light being recorded by using a faster shutter speed.

If you have a light background and your subjects are too dark, then you'll need more light. If the reverse is true, you'll need less light.

Remember, I did not use any external lighting to create the images in this book. In the portraits shown above, the family is in a shaded area, but they are well lit. The sun was coming in from behind the subjects, and the light reflecting off the brick wall and light floor boards lent a nice, warm glow. The background was a bit too bright, so my camera wanted to expose for the highlights and leave my subjects too dark.

This may happen to you, too. If you find yourself in this situation, you can adjust your exposure manually. On the iPhone, tap the focus box on your subjects, and an exposure slider will pop up. Drag the slider up to brighten the overall exposure, or pull it down to reduce the exposure.

In this case, I raised the slider until my clients were properly exposed. This made the background brighter, but I was willing to sacrifice some of the

background detail so that my subjects would be properly exposed.

For the next shot, I moved my clients to the left, where we had a darker background. The backlight from the sun separated the family from the dark background. The light bouncing off of the brick building and wooden floor boards bathed the front of the subjects with light. My iPhone automatically exposed the image perfectly, since the scene was well lit.

"Achieving a proper exposure is essential for every portrait. Take your time with this."

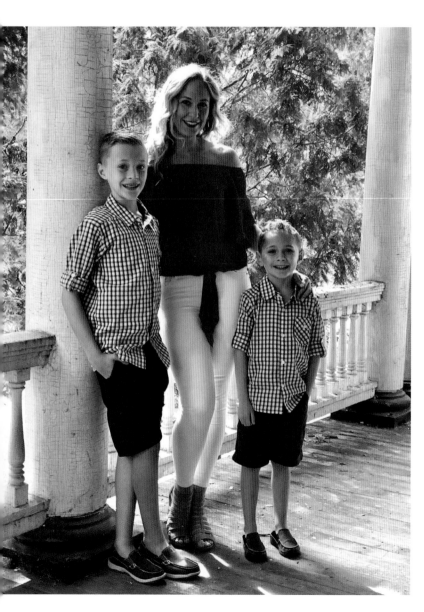

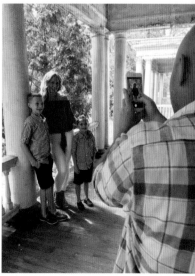

below. Setup shot for photo of mom and boys.

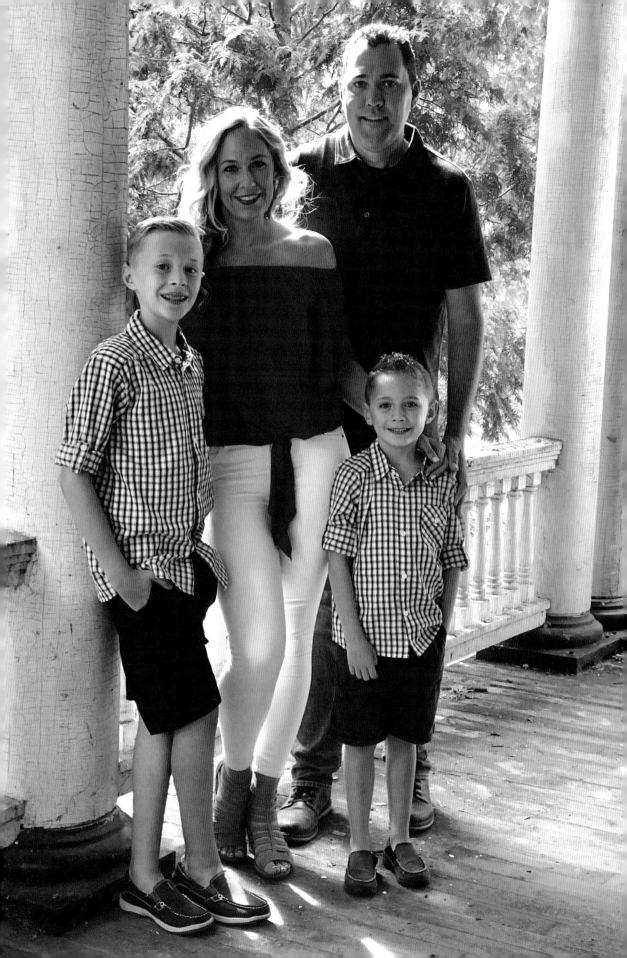

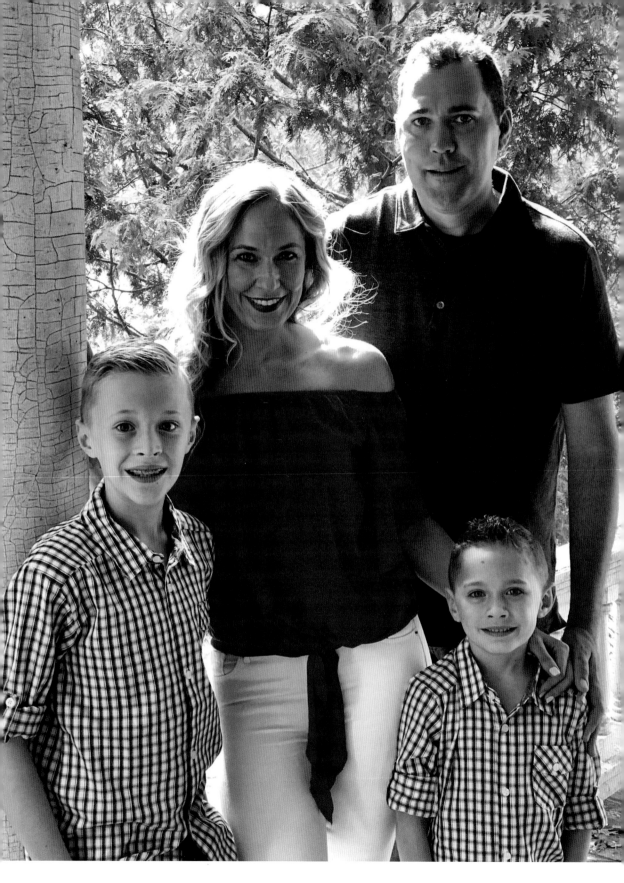

"When your exposure is correct, there is a good range of tones (for an average scene), with detail in the hightlights and shadows."

top and bottom. Setup shots for right image.

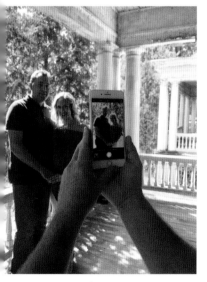

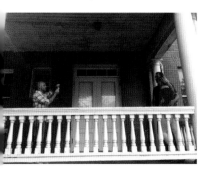

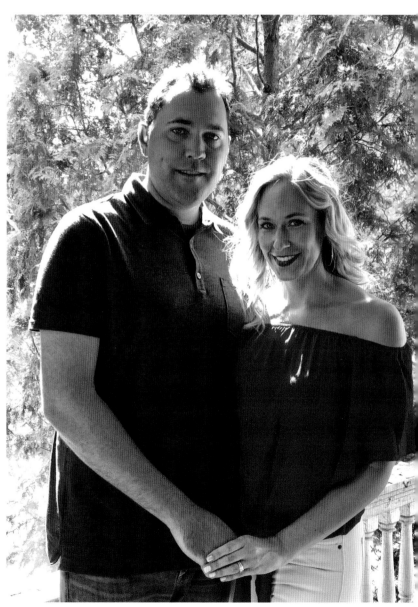

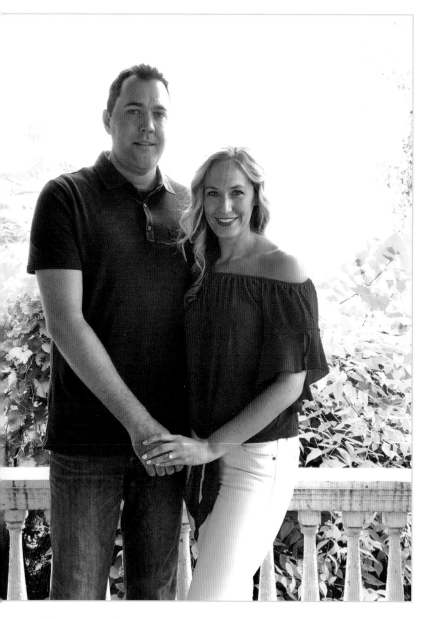

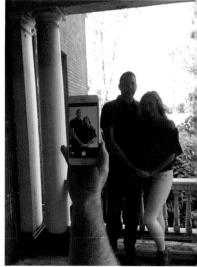

above. Setup for left portrait.

Breaking the Rules

When it comes to photography, there are rules to follow, but it's fun to break them at times. Sometimes, you might like the results; other times, you won't be happy, and you'll be reminded of why the rules exist. Don't be afraid to try different lighting situations. If you have already nailed your exposure, experiment and have fun. Sometimes, a blown-out background

"A bright, blown-out background can sometimes add drama to your portraits."

can add a little bit of drama to your portraits.

Here (pages 15 and 16), I had the couple stand in two different areas: one with a dark background and one with a bright background. It's up to you, as the artist, to determine which look is best.

My advice is, once you find your sweet spot where the lighting is good, get creative and mix things up a bit. I often place my clients in good light, then let them interact naturally. If they need help, I will provide a little direction to get some emotion.

Open Shade

Working on a covered porch can keep highlights from appearing overly bright and will make it easier to achieve a proper exposure. In the photographs of the two boys on the following pages, you can see the beautiful light bouncing onto the kids' faces. You can also see catchlights—the reflection of a light

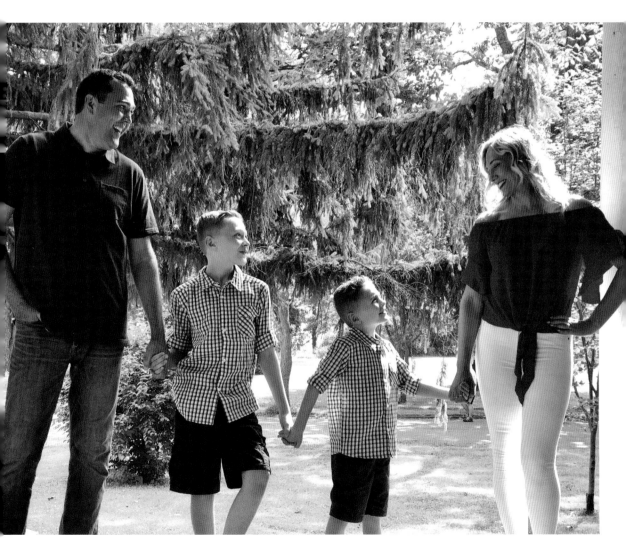

"Working on a covered porch can keep highlights from appearing too bright and make it easier to achieve a proper exposure."

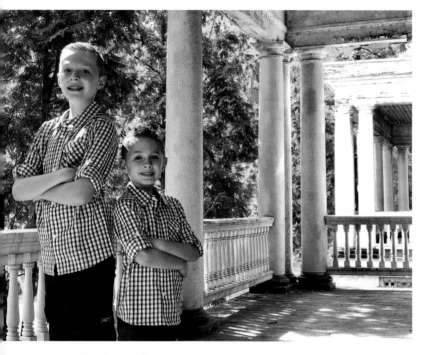

above. Setup shot for left photo.

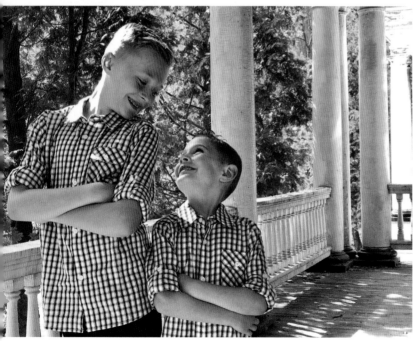

above. Setup shot for facing-page photo.

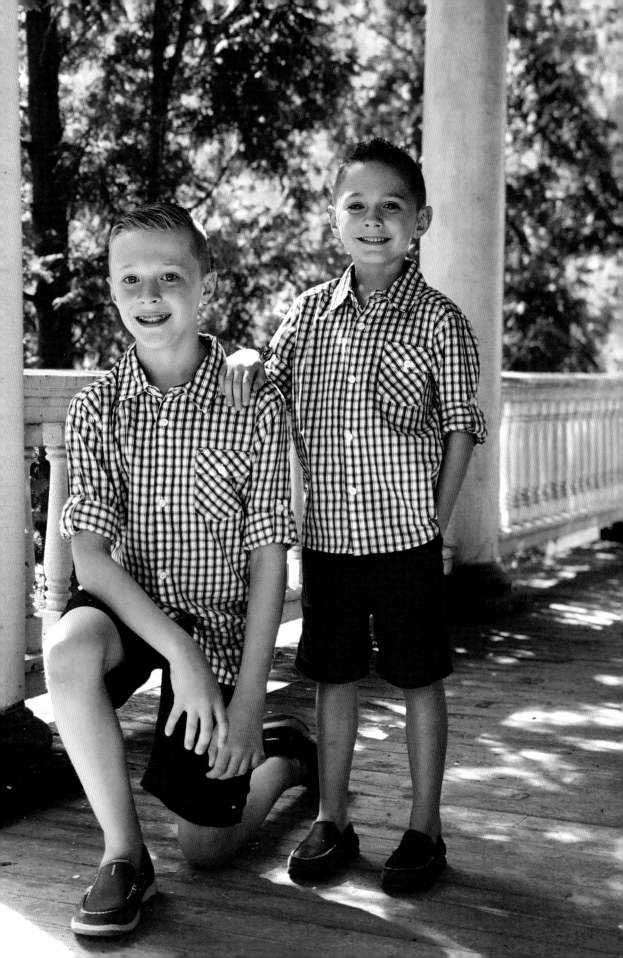

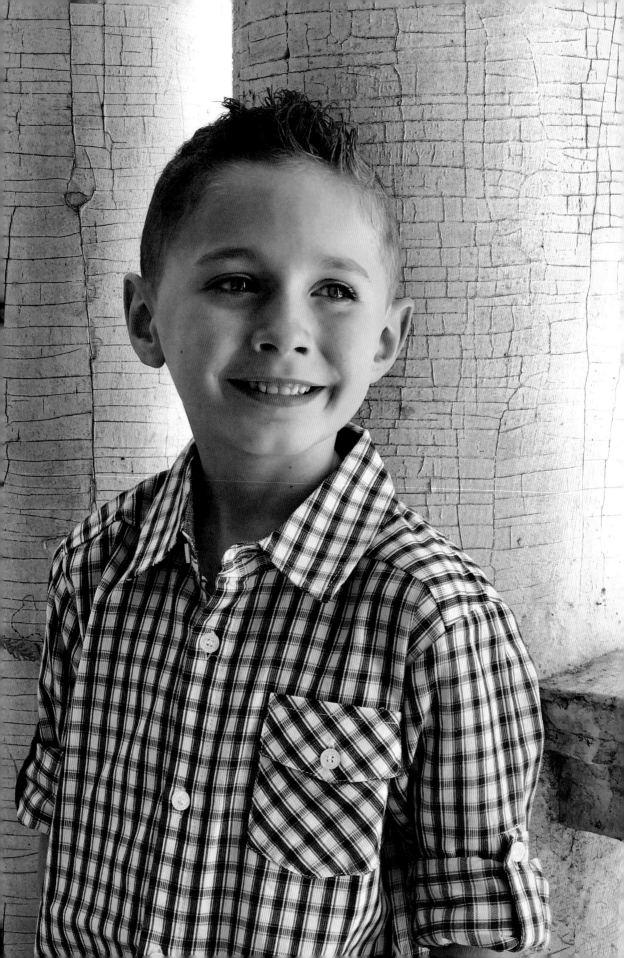

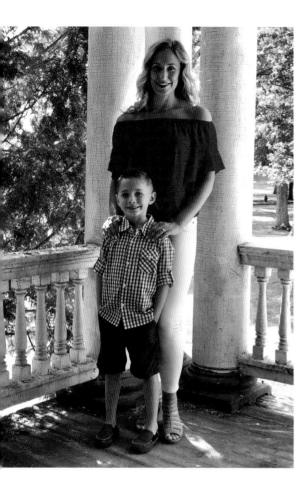

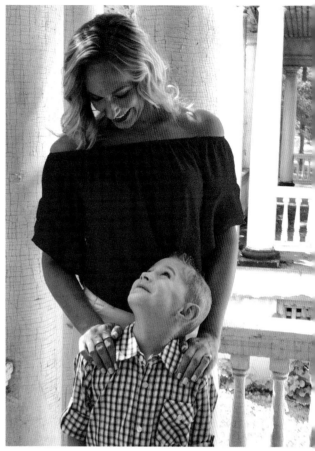

source that produces a bright highlight in the subject's eyes.

In the image with the solo boy (previous page), I had him look at a pillar that was reflecting light. You can see the pillar in the catchlight in his eyes. The pillar gave us soft, beautiful light, and the catchlight made the child's eyes "pop," giving them life.

"Search for a location that provides a variety of areas to shoot in."

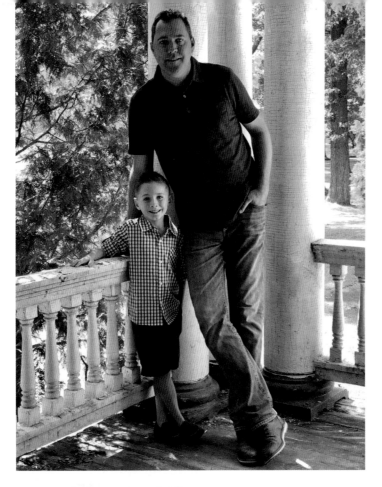

"Portraits with one or more subjects should show the relationship between the individuals."

above. Setup shot for bottom image.

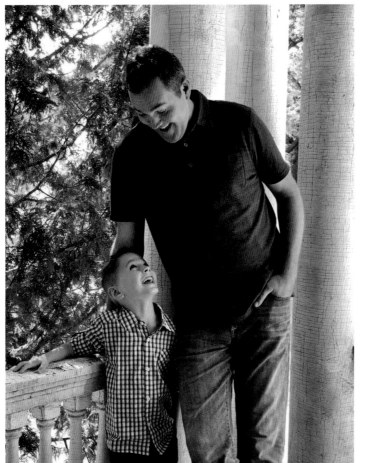

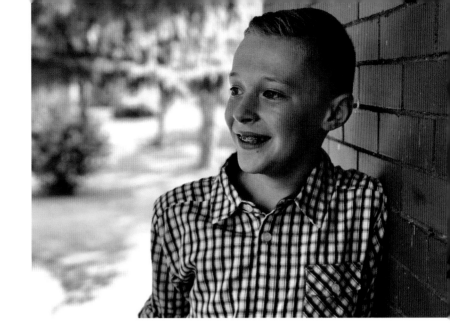

Above. Setup shot for bottom image.

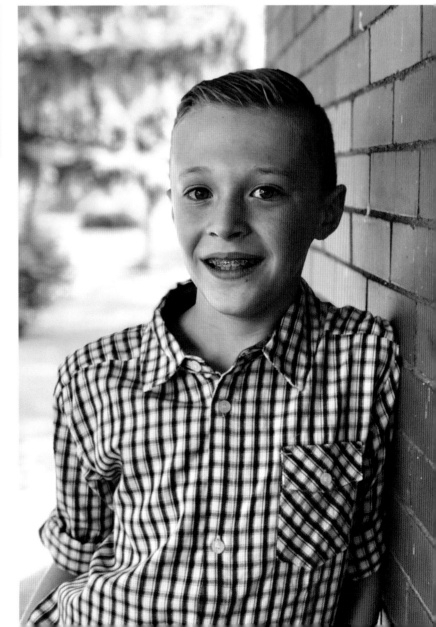

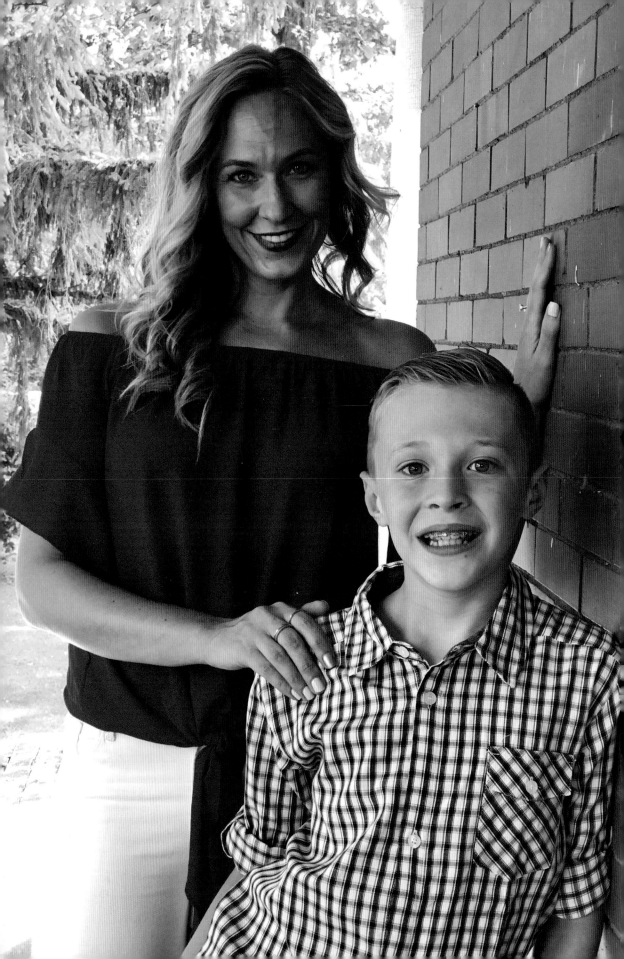

"Take care to ensure that the clothing your subjects wear coordinates and make sense for the location in which you are photographing."

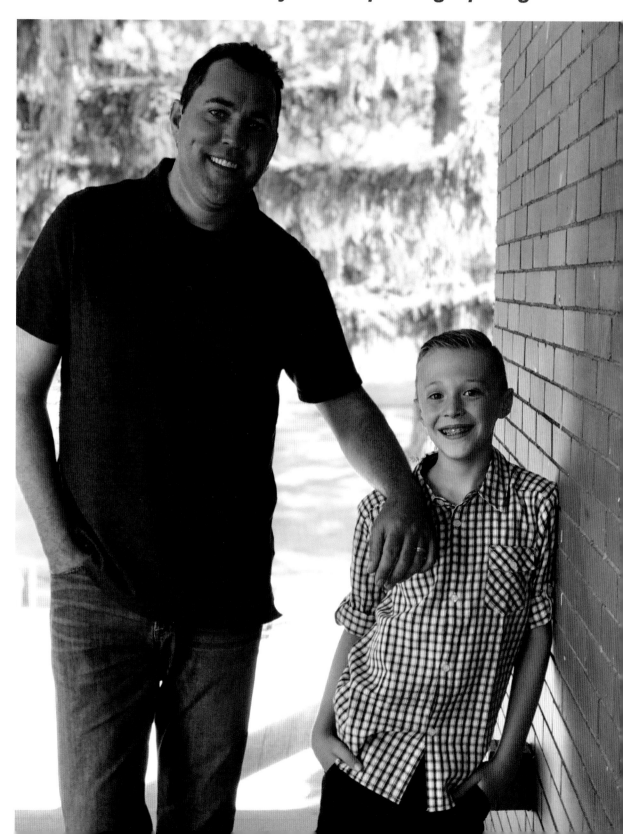

Natural Poses

Natural poses are wonderful, especially in casual settings. Consider capturing photos of your family moving in a way that comes natural to them. Have them walk toward you, document their interactions and affection, and capture images of them enjoying each other's company. Relationships matter, and interpersonal connections will be easy to see in your photos when your subjects are photographed as they are.

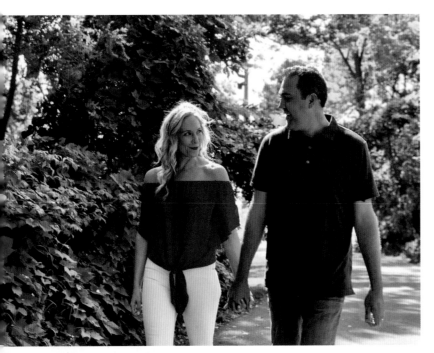

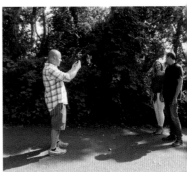

above. **Setup shot for left photo.**

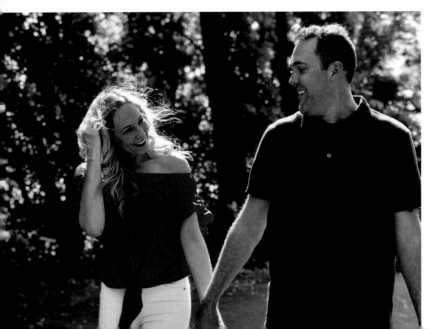

above. **Setup shot for left photo.**

"Look for a variety of expressions, from serious to playful, for better coverage in your images."

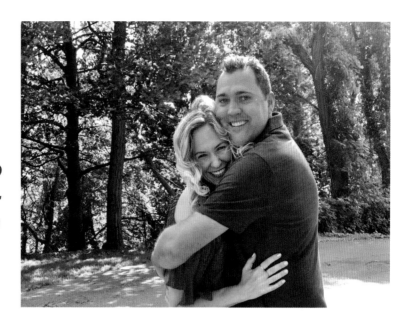

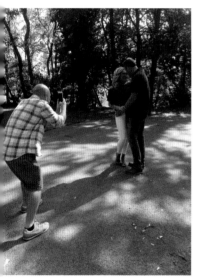

above. Setup shot for bottom photo.

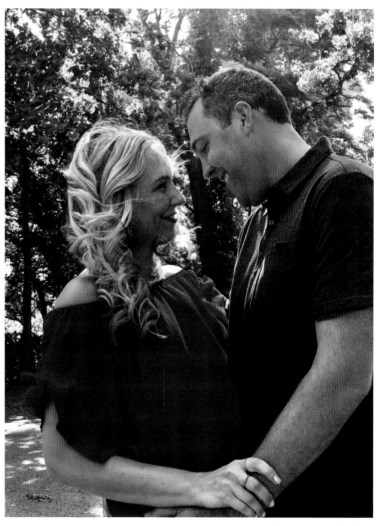

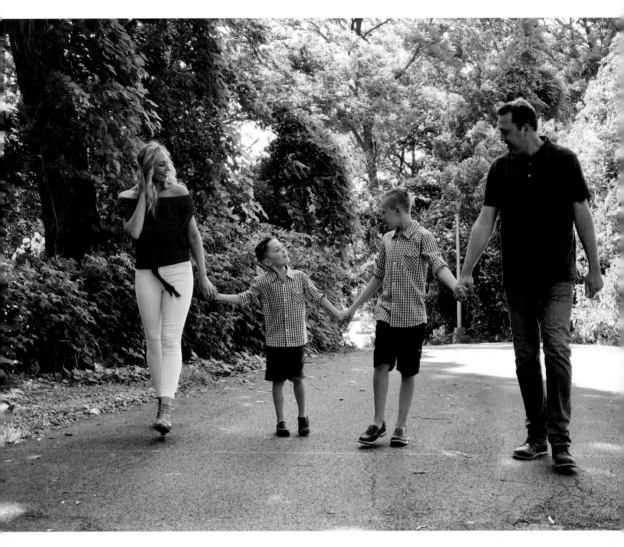

Shake Things Up

One location can offer plenty of backgrounds, and many looks, for your images. Consider the way the scene looks at various times of day, from different vantage points, and with different choices in editing. Though all of the photographs on this page spread were made in the same area, you can see that each image has a very unique feel.

"One location can offer plenty of backgrounds, and many looks, for your images."

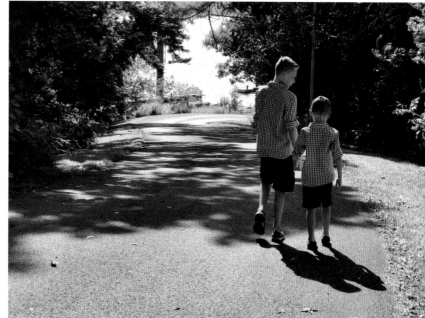

above. Setup for right image.

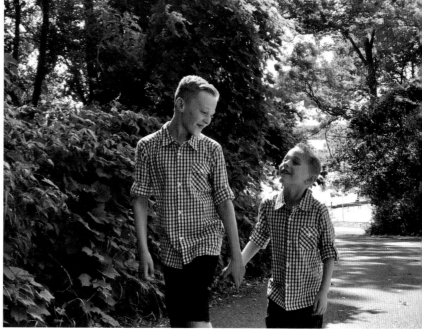

above. Setup for right image.

above. Setup for left image.

"Try putting a lot of distance between two or more subjects, from front to back, in the frame. The closer subjects will be larger and in sharper focus (if you chose to focus on them!) than anyone farther from the lens."

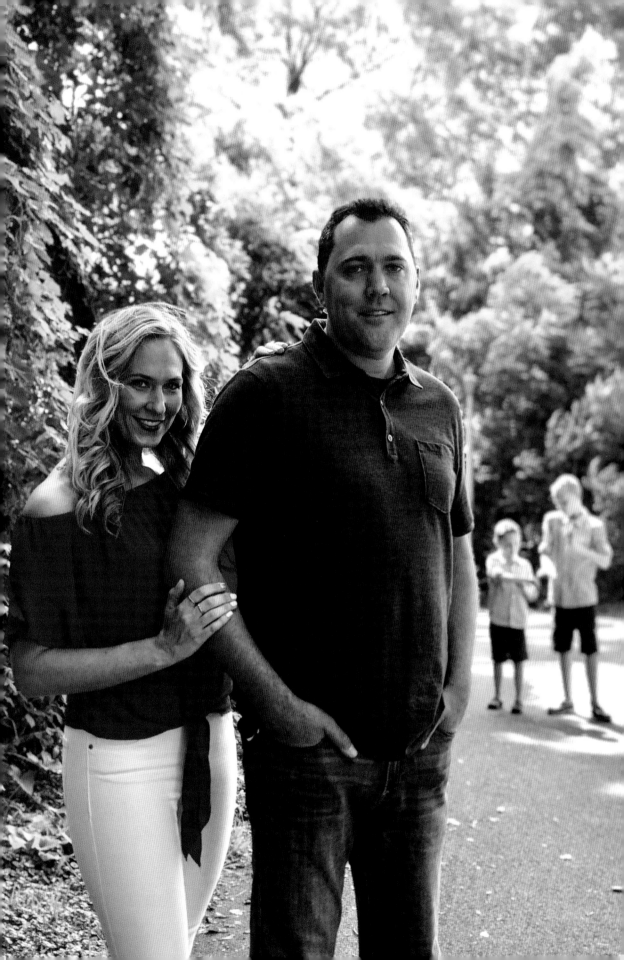

"Scan the background of every shot to check for unpleasant distractions and fun surprises."

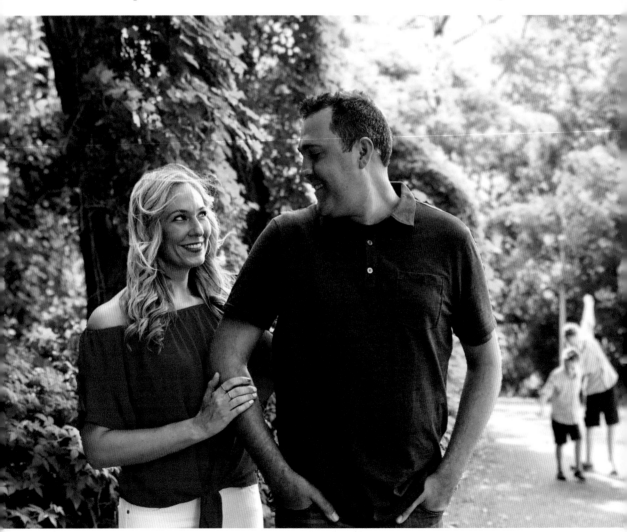

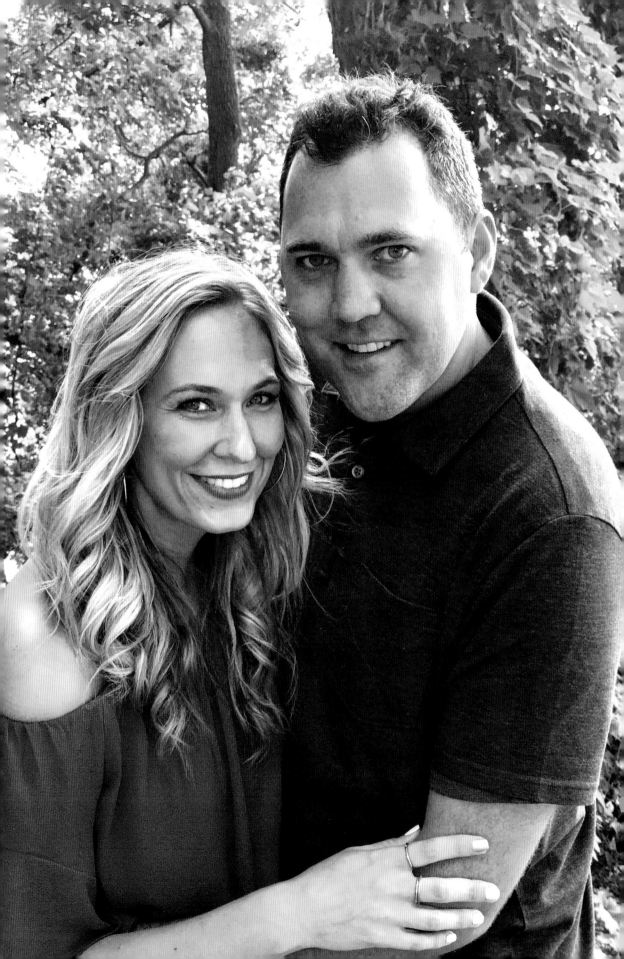

Family Fun

After completing the more formal, smiling, "safe" shots on the porch, then getting successful images in a second location, we went to a third location for more natural, fun photos. It was time to get artsy. I would have been happy and confident with the shoot if we were to end the session after capturing the first two series, but I happen to have a reputation for my dramatic images—the "end with a bang," "hail Mary," "toss-to-the-end zone" shots.

At this point, my clients were completely relaxed and feeling good. It was time to have some fun!

In our shooting location, there was a large, steep hill. We had nice, blue skies with some wispy clouds that made for a beautiful background. We had the subjects climb the hill, and then positioned them

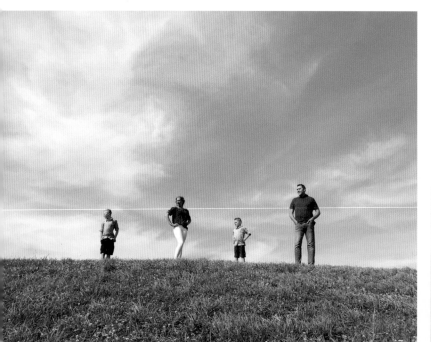

below. **Setup for left imag**

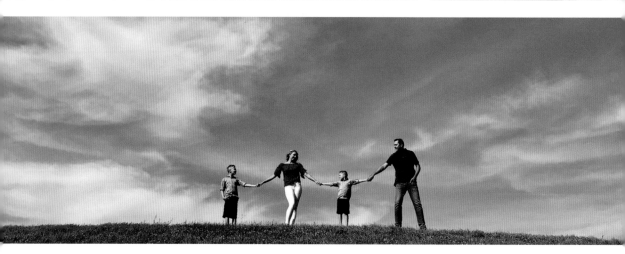

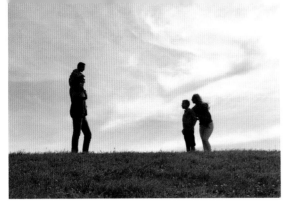

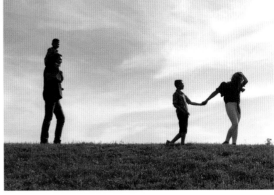

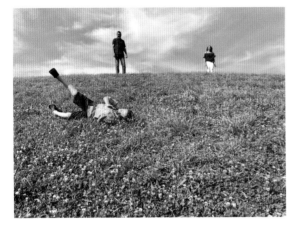

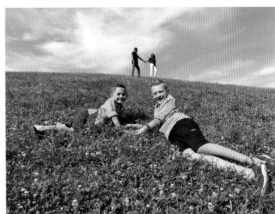

at the top so I could shoot from below. We spaced the family out a bit since this was a big landscape photo.

The sun was setting to camera left, which gave us dramatic lighting.

Next, I repositioned myself on the other side of the hill to shoot some silhouette photos. Creating silhouette images will allow you to offer your clients a more diverse selection of images. To capture a silhouette, ensure that the light source is behind your subject and that little to no light is illuminating them from the front. I usually end a session with a silhouette.

Whenever you have kids in a session and you say "it's a wrap," they will let their guard down and be themselves.

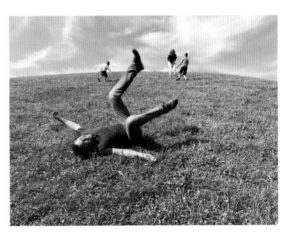

Be sure to have your camera ready to capture their antics and personalities.

In this case, the kids decided to roll down the hill, and I was ready and waiting for them. The father decided to join in on the fun. I love the reaction of the mom in the background!

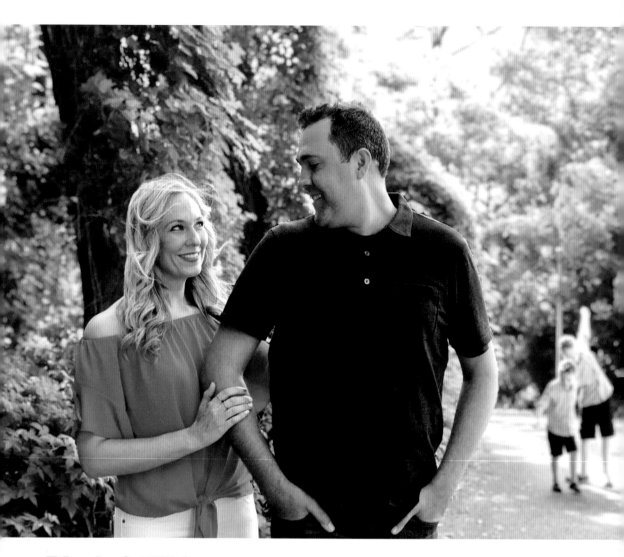

Black & White

Converting an image from color to black & white simplifies the photo and distills it down to its core elements. It's one great alternative to creating a diversity of looks in your images. Above and on the following page, I've presented select images converted to black & white.

There are several ways that you can convert your images to black & white. I'll cover this in detail in the last section of the book.

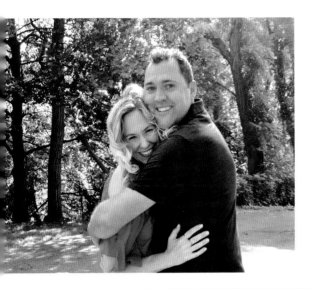

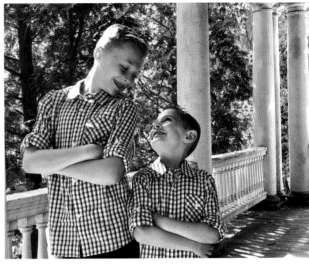

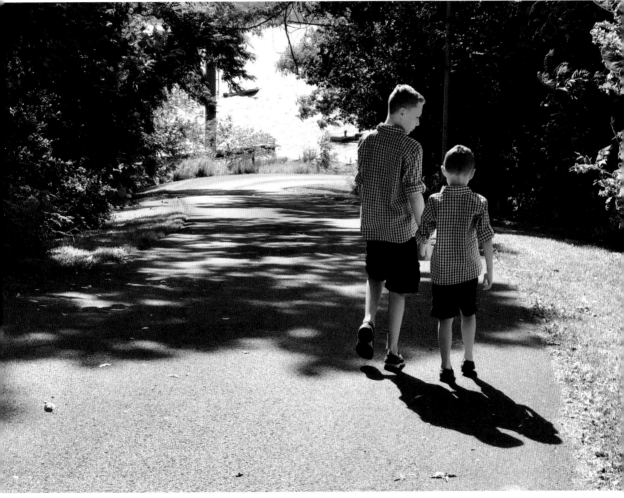

Rustic Charm

We photographed this session close to sunset for a golden hour/twilight hour look.

Quality of Light

The best way to start a session is to find where the best light is at your location. I often start in the shady areas, just to get warmed up. Note where the sun is coming from. Is it partly cloudy, so that it is shady one moment and sunny the next? This might be

"Learn to understand light and the way it impacts your image for pro quality portraits."

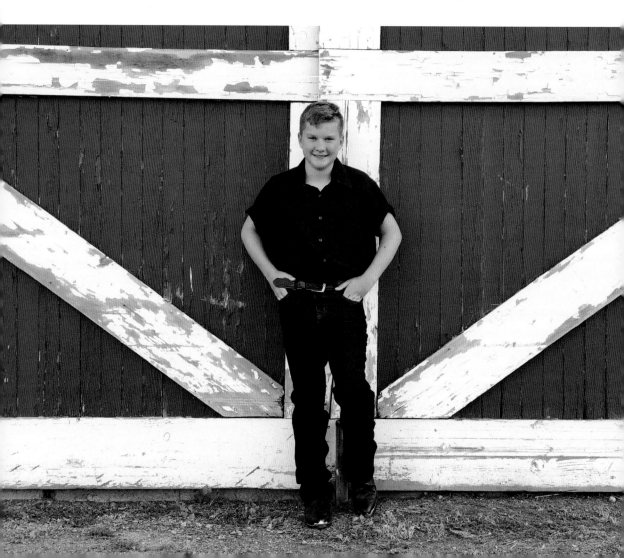

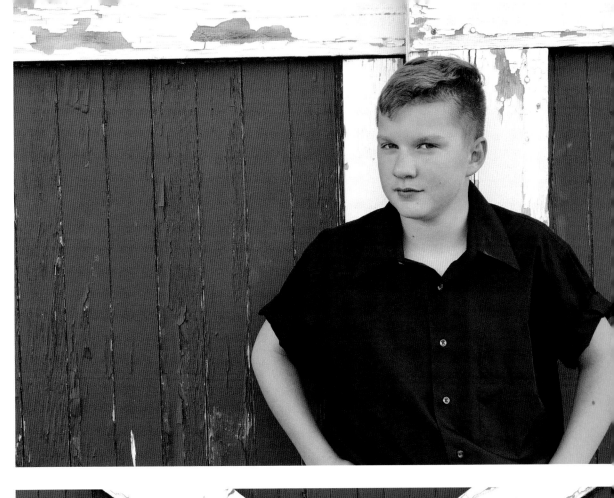

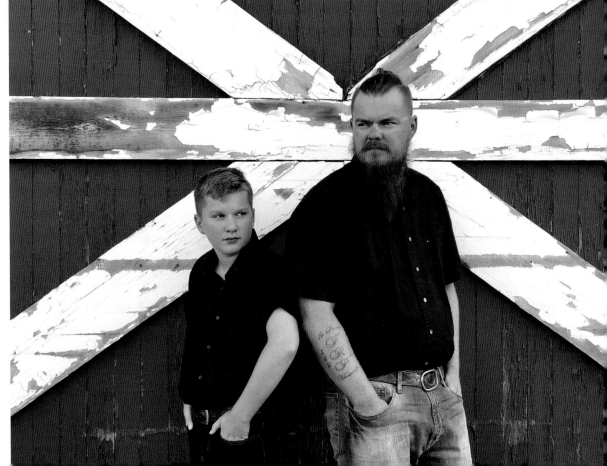

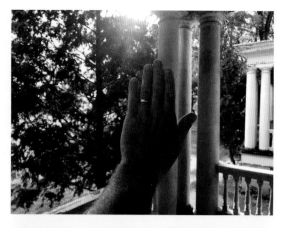
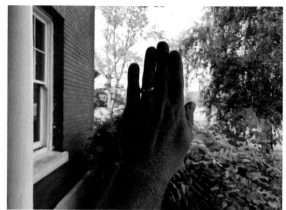
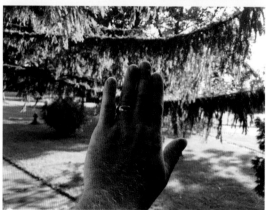

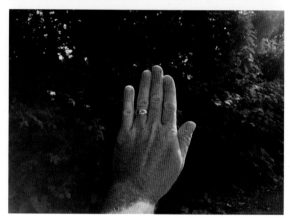

challenging at first, but in the end, it you will produce a wide variety of images. You don't have to find the shaded areas and stay there. Venture out into the sun and keep creating.

Here's a helpful hint for finding great light: Before you begin to shoot, hold your hand out. Notice how the light hits your hand. Note the direction of the light. Be aware of the shadows. The light you like best will depend on your style of shooting, but in the series above, I prefer the top-left and bottom-right lighting conditions. For me, the light in the bottom-right photo

is ideal; there is backlight and a dark background.

Golden Hour

Shooting during golden hour (the hour after sunrise and the hour before sunset) is ideal, but you won't always be able to take advantage of the warm, flattering light due to schedule conflicts or the presence of an overcast sky. At this time of day, the sun is low in the sky. This helps reduce the unattractive shadows known as raccoon eyes that are created by the sun when it is directly overhead.

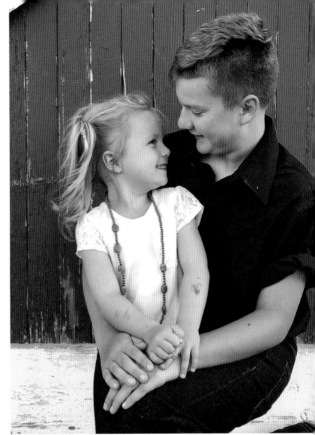

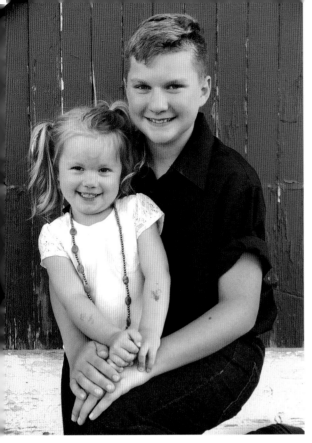

below. Setup photo for image series on this page.

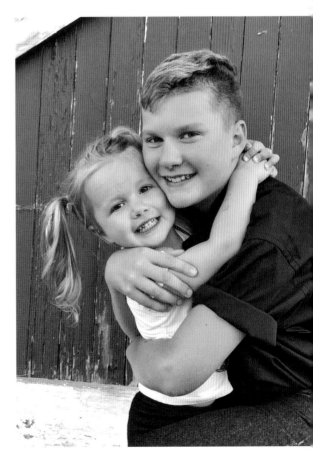

"Look for soft light to avoid unflattering shadows on your subjects' faces."

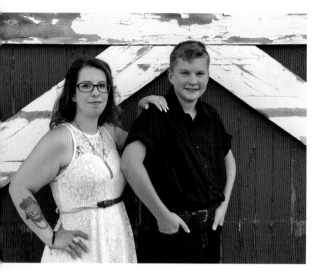

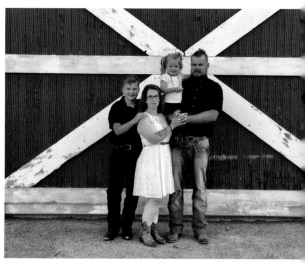

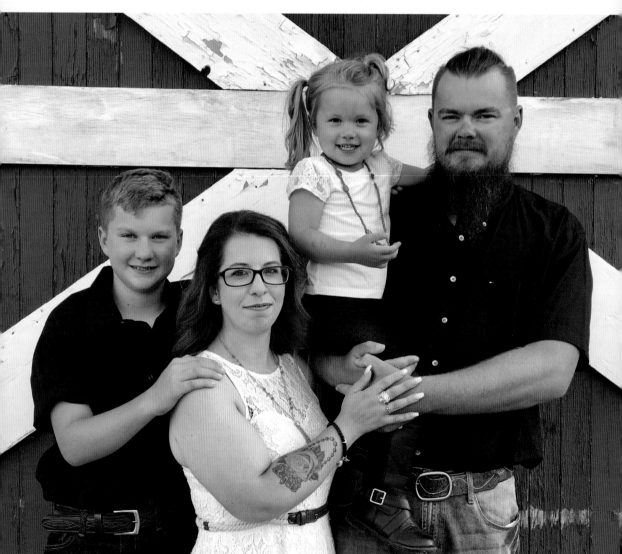

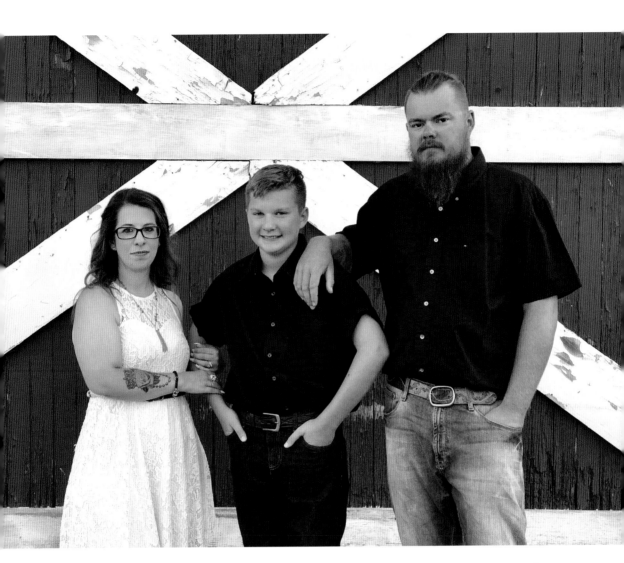

"Complete all of your groupings in one location before moving on to the next."

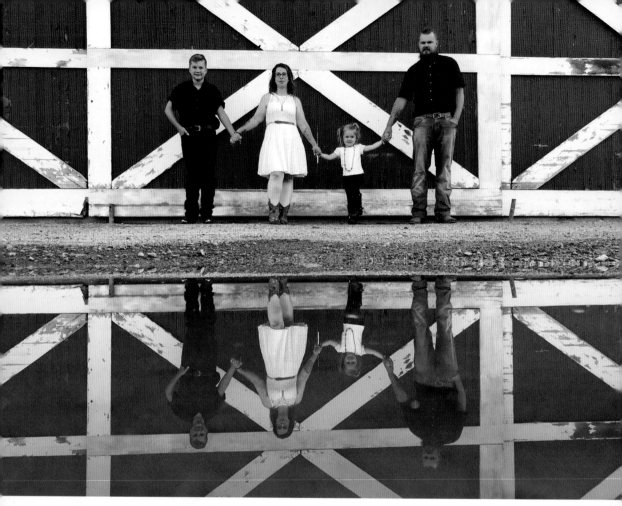

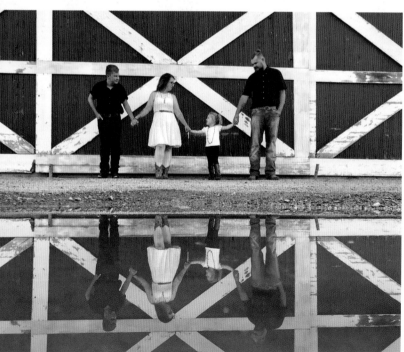

above. **A low camera angle allowed me to create this reflection series.**

Reflections

One way to help turn an ordinary image into something extraordinary is to find some reflections to include in your photographs. This will add that little "something extra" to the family's portrait collection. Mirrors, windows, puddles or anything else that is reflective can help you create added depth and drama in your photos, so it pays to always be on the lookout for reflective objects in your locale.

"Include reflections of the family in your photos when possible for added interest."

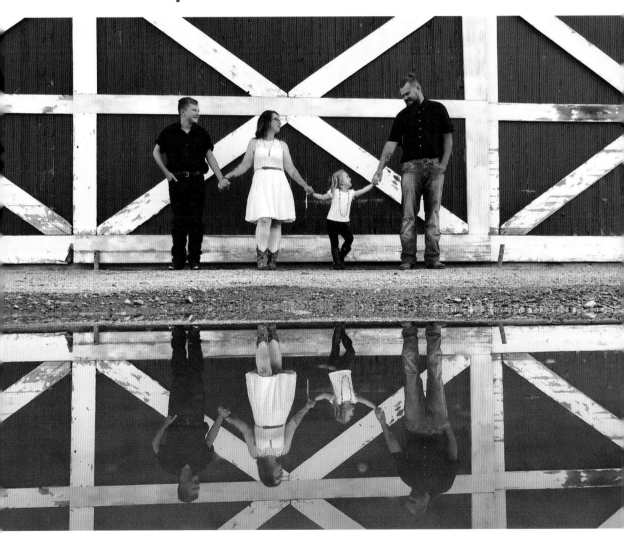

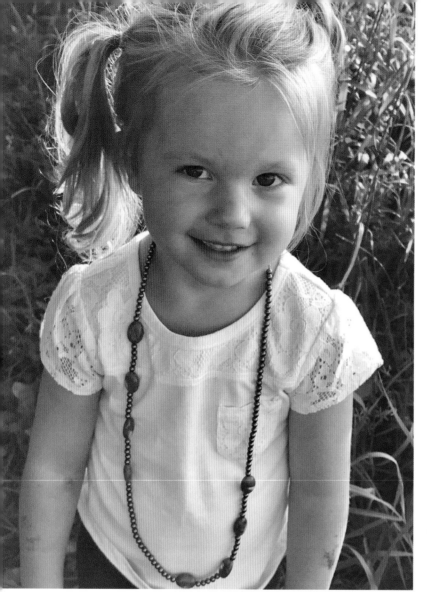

top and center. Setup shots for this series.

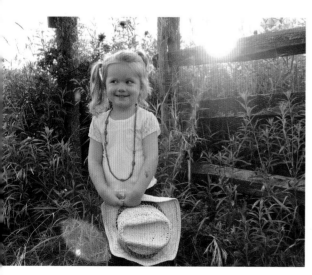

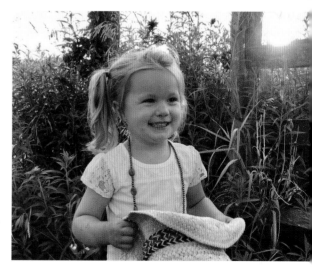

Sunbursts

Backlight is wonderful with a dark background, but you can really add an artistic flair in your images when the sun pops through. You never know how your lens will react to the sun. Take a photo, study it, and then make necessary adjustments from there.

The first image of the girl and her dad shows a beautiful moment, but the sun was too direct. I moved to my right so the sun wasn't so centered. In the bottom image, the sun is peeking into the scene, providing beautiful flare on the subjects, and some eye-catching light rays. It's perfect.

"Shoot into the sun to capture an artistic sunburst effect."

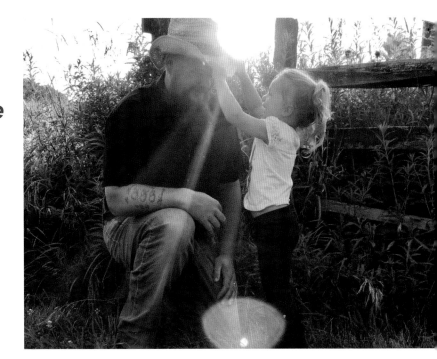

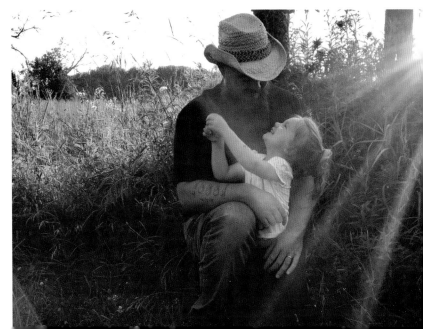

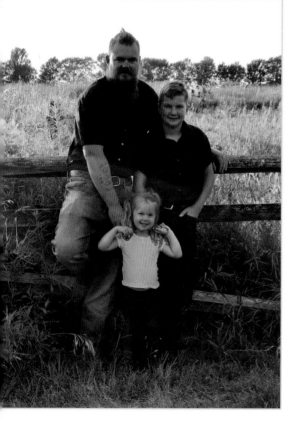

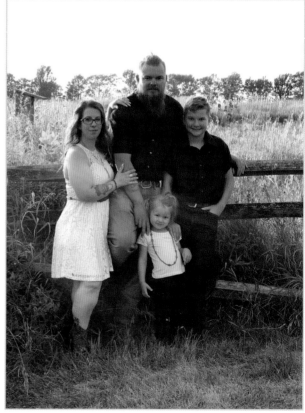

"Take advantage of golden hour light to add warmth in your family portraits."

left and right. Setup shots for the images on this page spread.

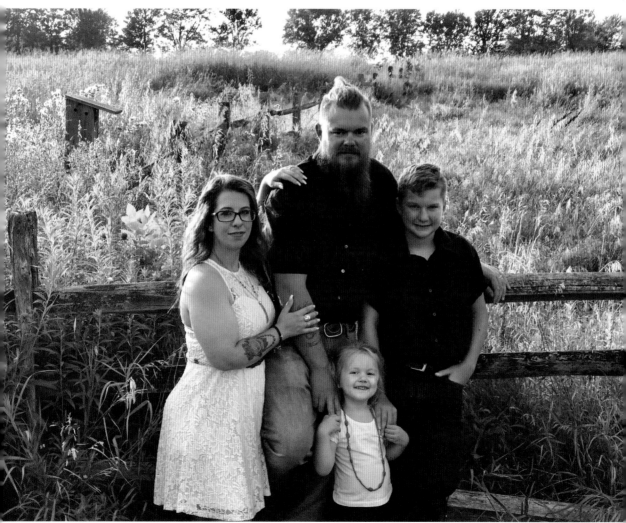

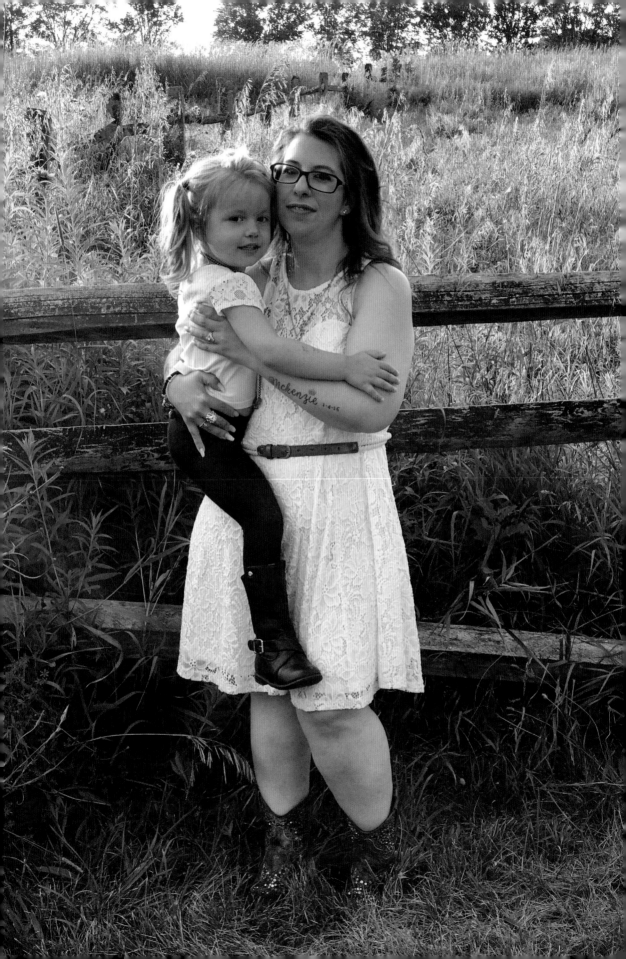

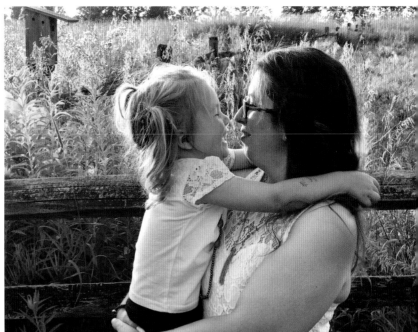

above. **Setup shot for image on previous page.**

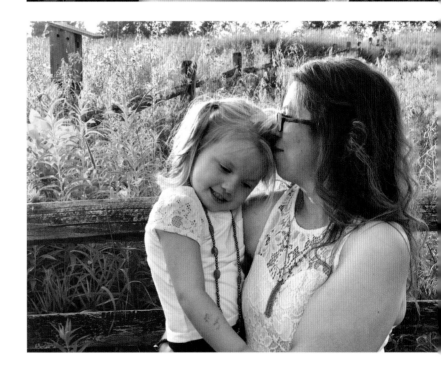

"Compose portraits so that any horizontal lines in the frame do not intersect the plane that the subjects' heads occupy."

"Capture a scene in both vertical (portrait) and horizontal (landscape) formats. Each will have a different feel."

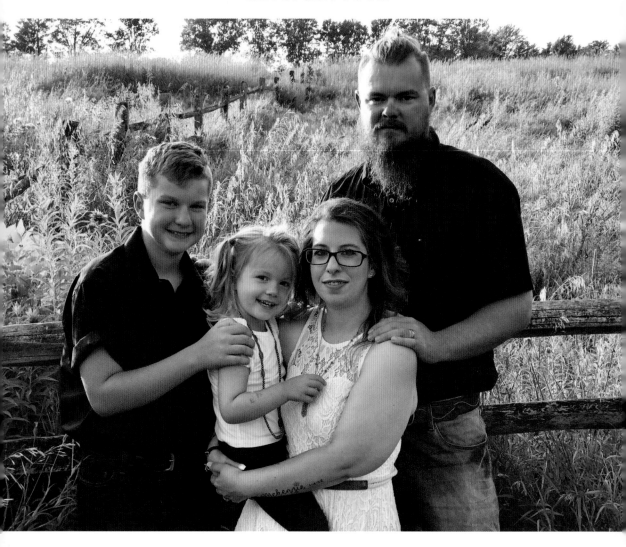

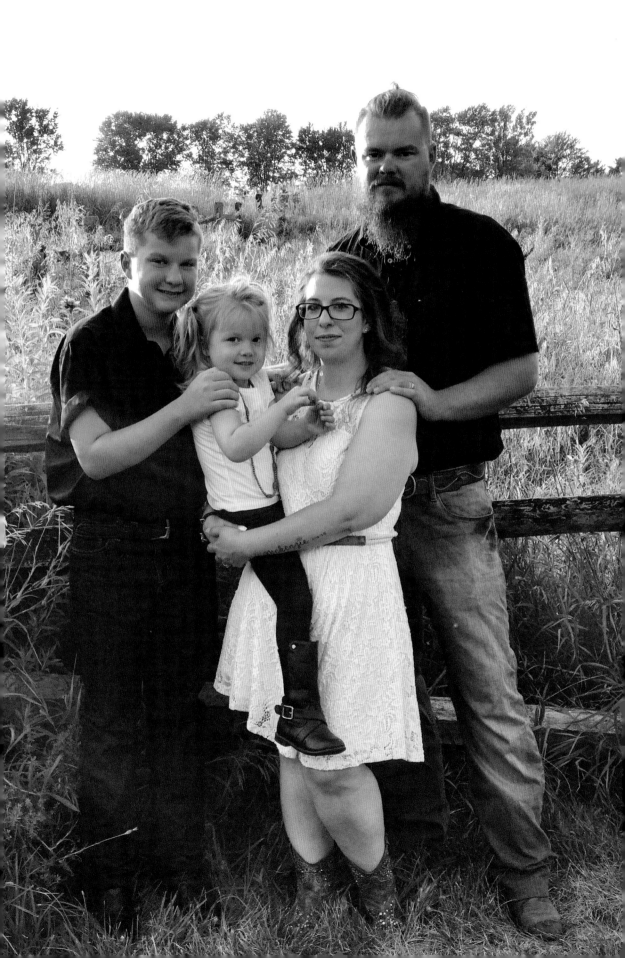

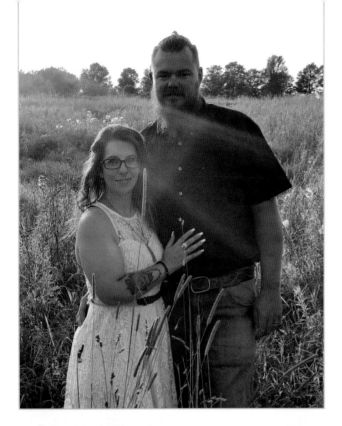

"Shoot into the sun to create interesting effects in a handful of your images."

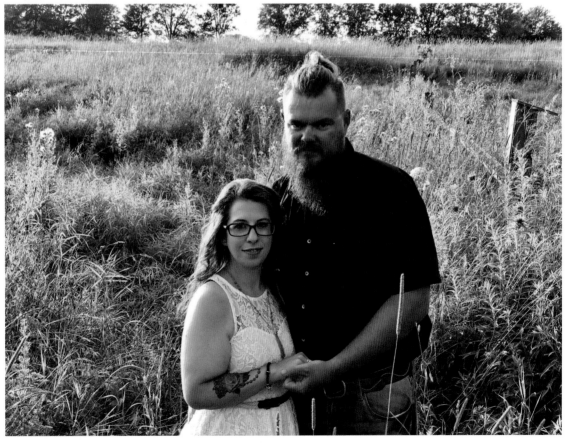

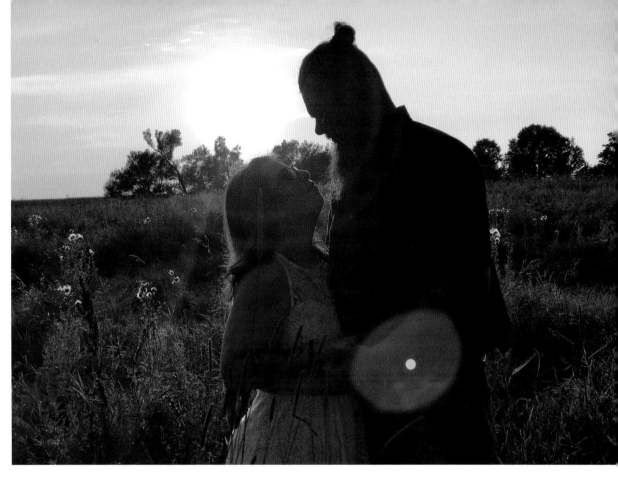
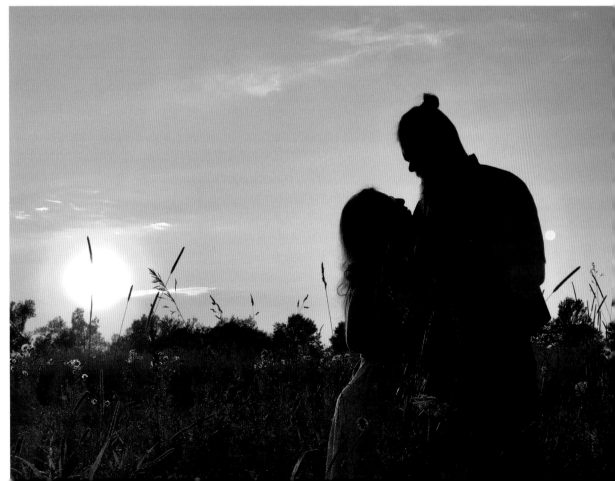

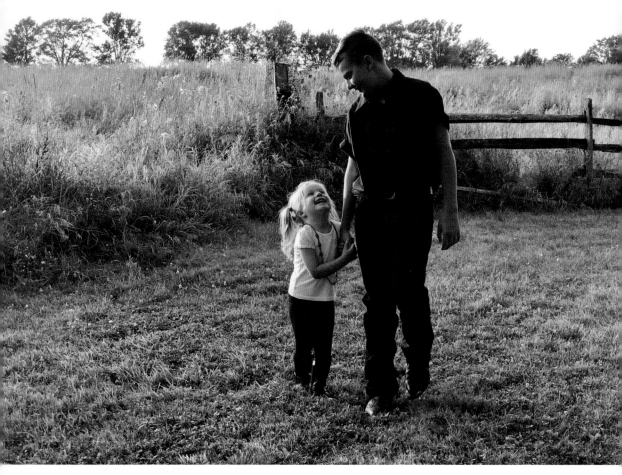

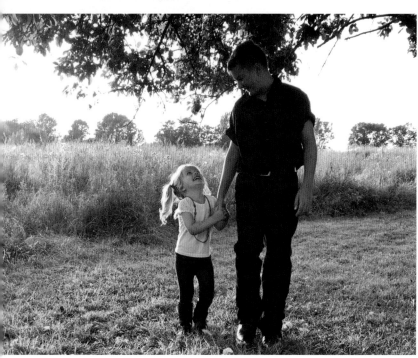

above. Setup photo for above image.

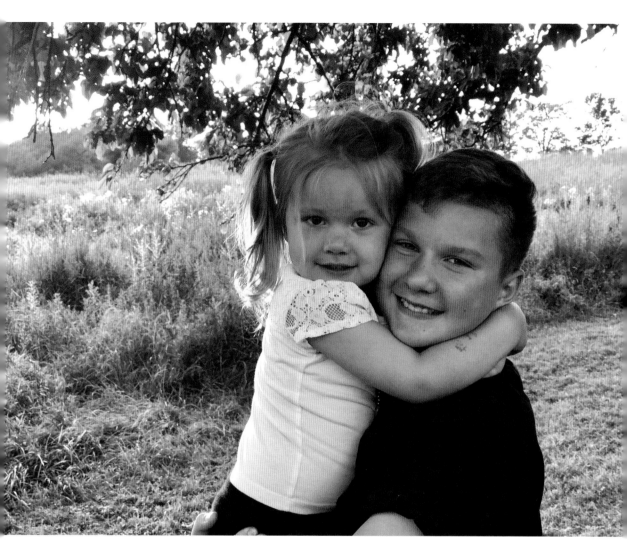

"Use implied lines in your images to guide your viewer from one face to the next. In the photos on the previous page, the implied diagonal line between the two kids' heads move the eye from one face to the other."

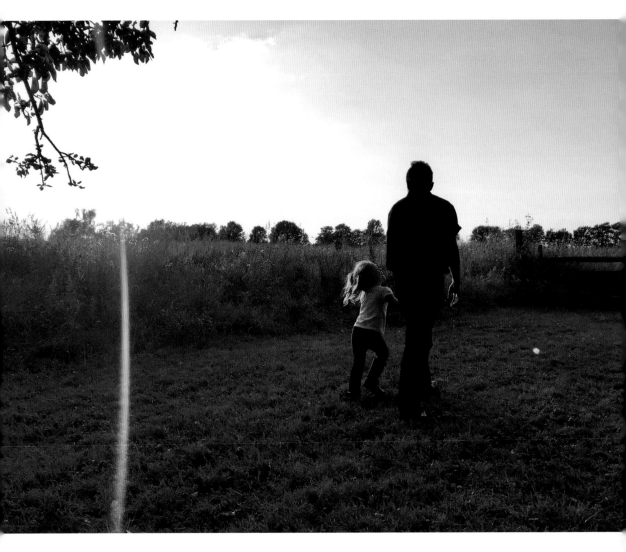

Lens Flare

When you shoot into the sun, you can sometimes see
the rays of the sun in your image. This can add a lot of
charm in your portraits. You might also get a lens flare
effect, which can show up as a haze in your photo—or
as odd spots of color. These can be left in for effect or
can easily be edited out, if the spot of color is small, as
it is in the image above. In the photo on the following
page, there is a lot of flare around the aberration, so
editing would be difficult.

"Be sure to capture some images of the family when they are not looking at the camera to produce a selection of portraits with a candid feel."

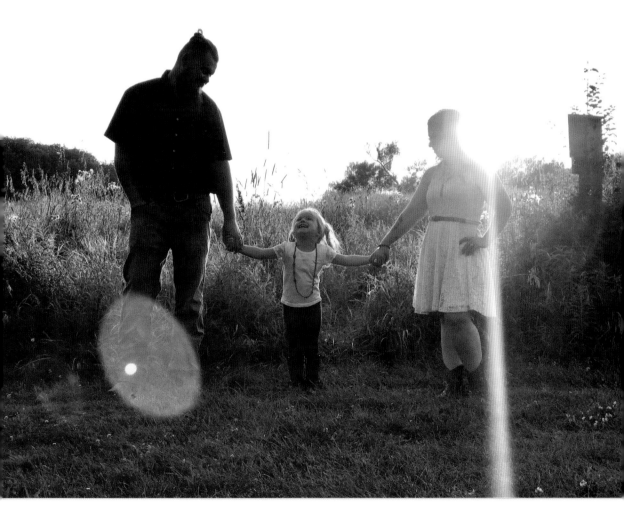

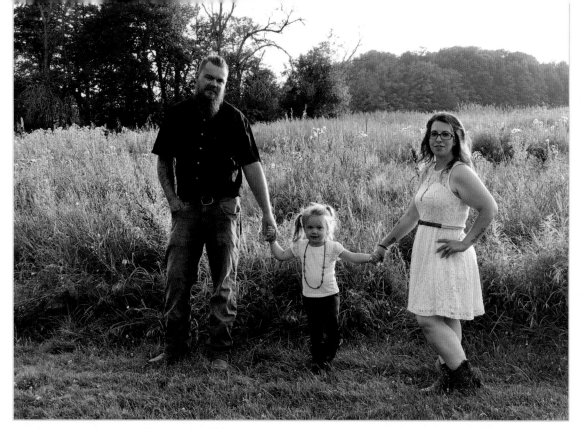

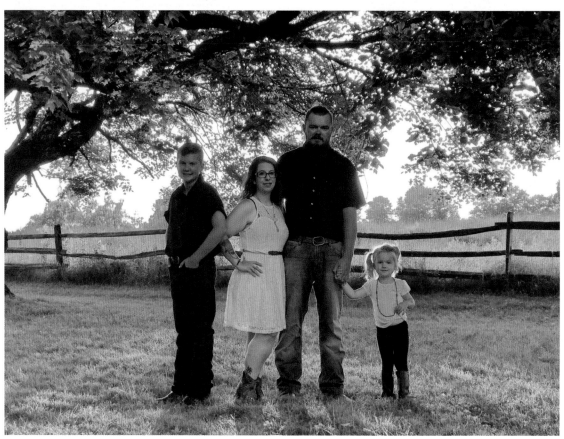

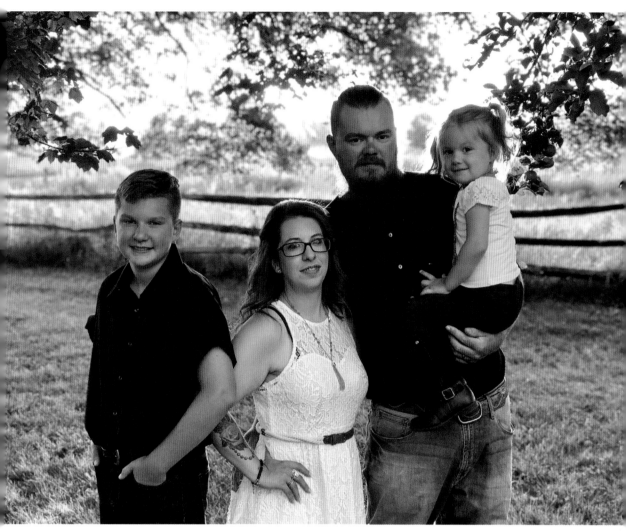

above. Setup photo
for right image.

"**Press your elbows against your
sides to better stabilize your
camera—or use a tripod—when
light levels are low. This way,
you can prevent motion blur.**"

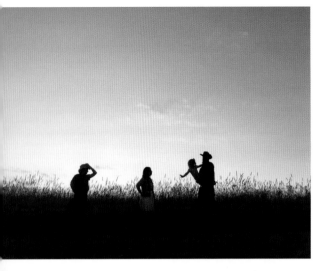

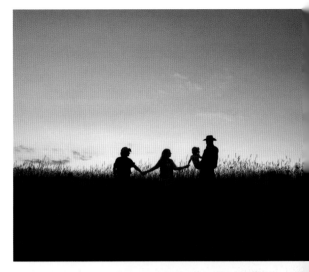

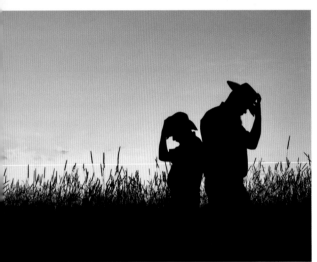

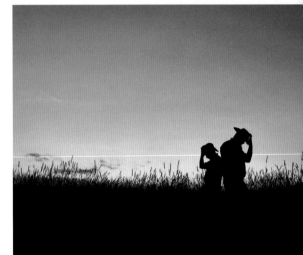

Silhouettes

As mentioned earlier, I like to end my sessions by creating a series of silhouette images when possible. It really doesn't matter what time of day it is. Shoot with the sky as a backdrop, then lower the exposure slider until you can't really see detail. Make sure your subjects are posed so you can see their profiles. Mix up the poses to give variety. Go in for a close-up, then back away for more of a dramatic landscape. Show the clients the images so they go home feeling confident and happy.

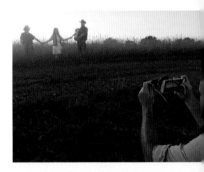

above. **Setup photo for top-right image.**

On the Beach

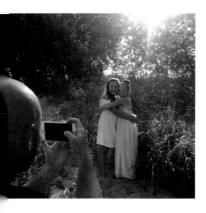

above. **Setup photo for image below.**

For this session, we shot early in the evening. It was not quite sunset on a day that was full of sun.

Simple Posing Ideas

It is important to ease your way into posing your subjects. Don't over-complicate the process by giving too much direction. This may confuse the people you are photographing and make them more nervous than they already are.

Place your subjects in good light and give them a simple posing directive, like "hug and smile." Start

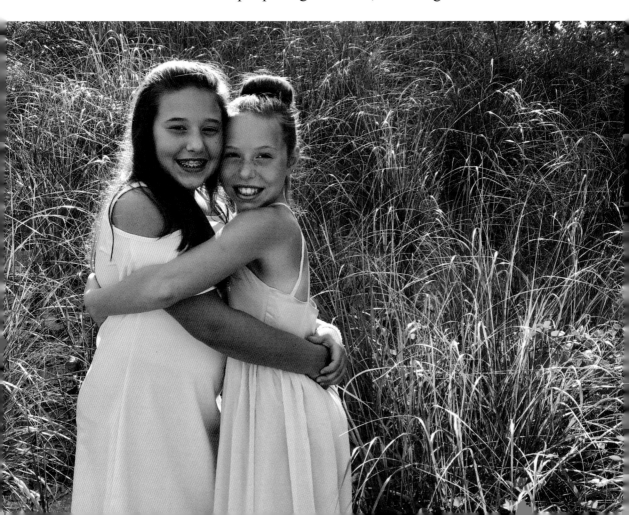

with a small group of one or two, and then add in more family members.

It's best to take a couple of test shots to gauge the lighting and composition when you are working with just a subject or two. Always be sure to capture some close-ups, then move back to show the whole scene. If the lighting doesn't give you the look you're going for, just move on and find better light.

"Start with a small group, and then add in other family members."

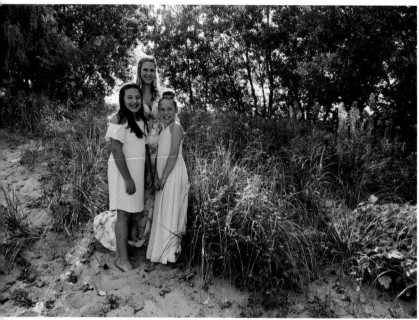

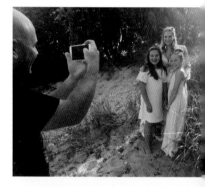

above. Setup photo for top image.

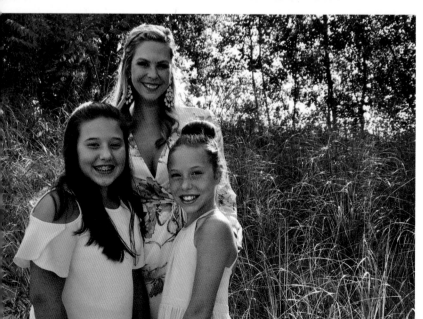

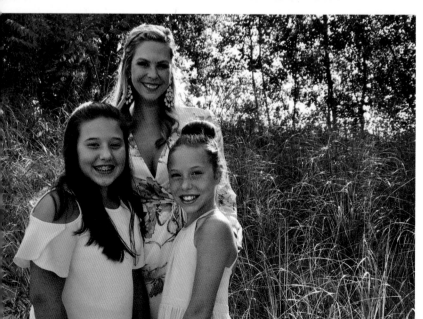

above. Setup photo for images on the following page.

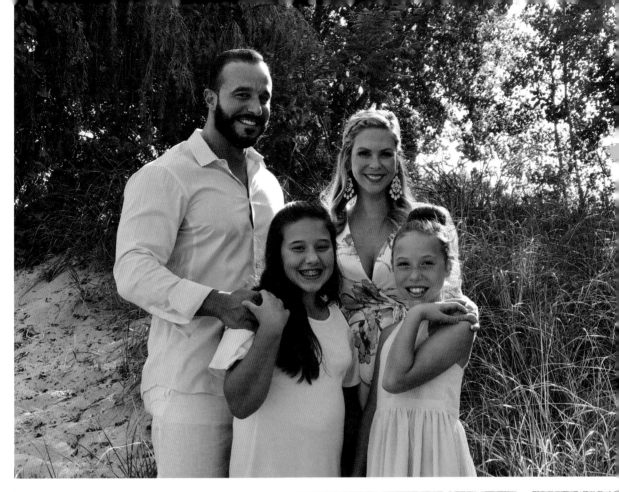

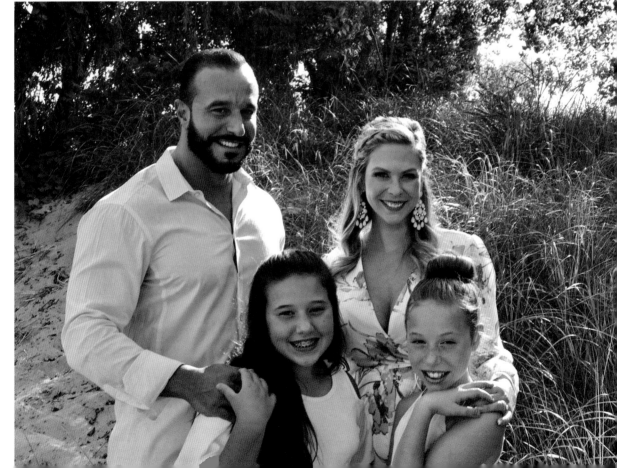

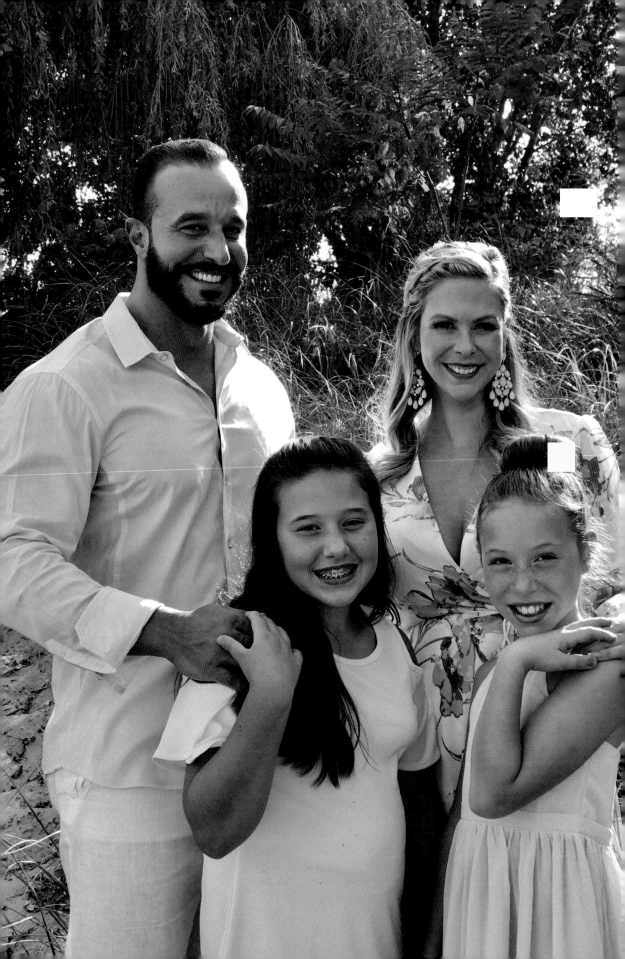

above. Setup photo for right image.

above. Setup photo for image below.

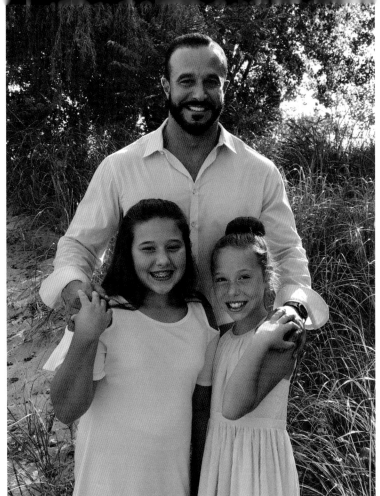

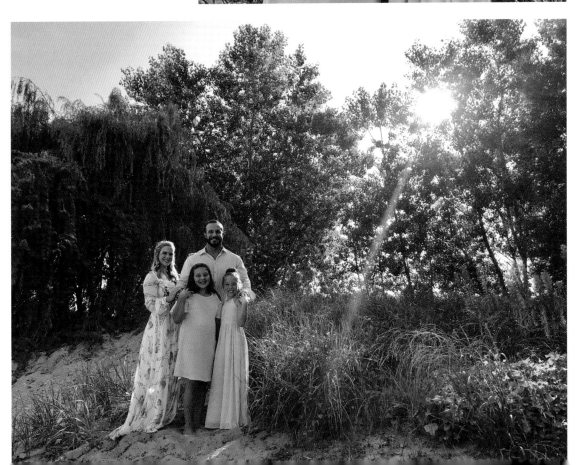

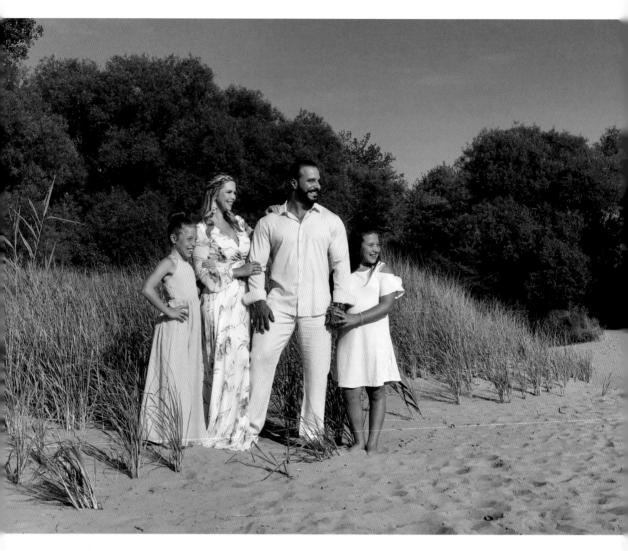

Image Format

For most of my portrait sessions, I usually shoot in a portrait format, with the camera held vertically. This is my go-to format whenever I am shooting close-ups. I also like to make it a point to create images that require me to zoom out or move farther away from my subjects. For those photos, I hold the phone vertically to create a landscape-format image, which will show off the entire scene.

Landscape-format images work great when we produce wall art or an album for our clients. When we

"Hold your phone vertically to take landscape-format images that show off the scene."

create wall art displays, we'll have the large landscape print in the middle and portrait-format images arranged around that print. In an album, we'll present portrait-format images that fill a page, and when the client turns the page, they will see a beautiful landscape-format print that runs across a page spread. Those landscape images create the wow factor in the album and on the wall. When you shoot close-ups, always leave some head space in the image

This will be especially important should you want to crop the image into a square shape. There are times when we are designing an album that we will present the images in a 1:1 square crop. Also, a 1:1 crop is popular on social media, such as Instagram.

No matter what format you choose, never forget to use the Rule of Thirds. We'll turn our attention to that rule on page 77.

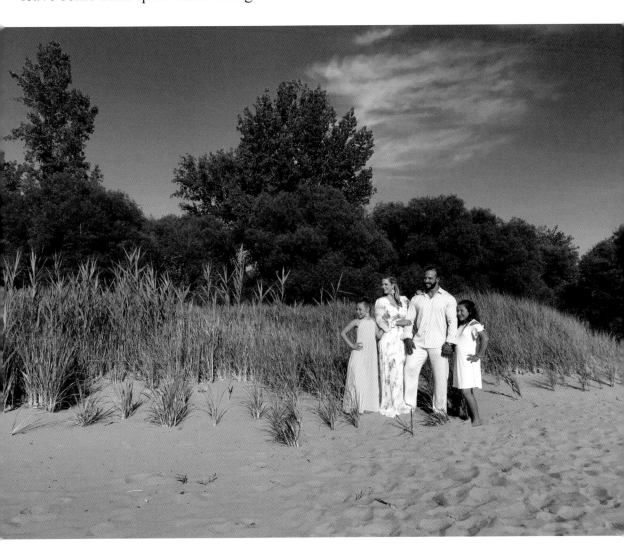

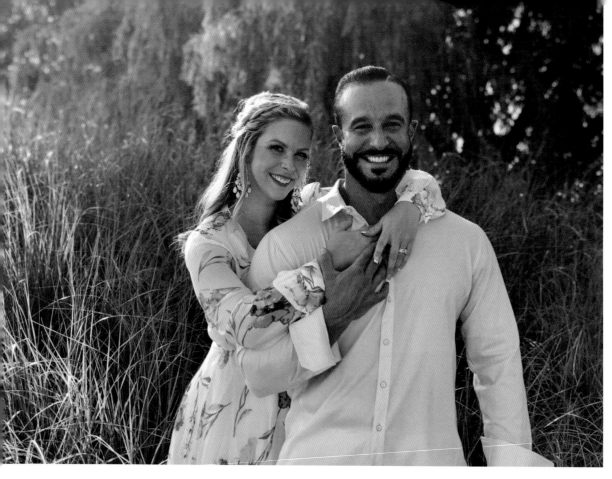
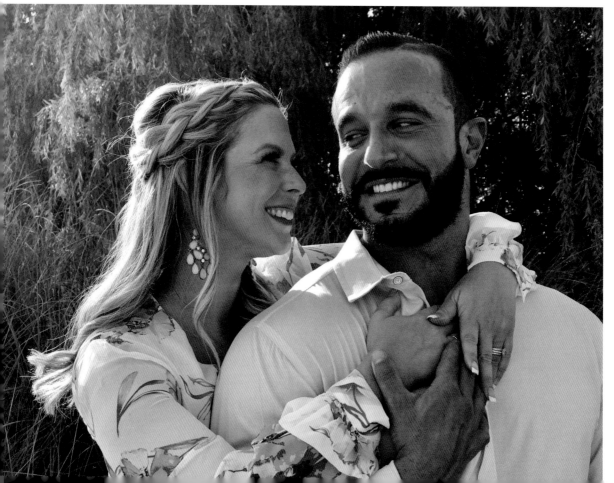

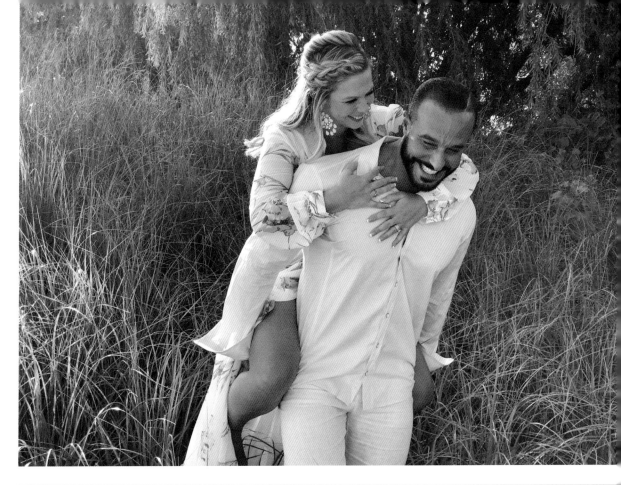
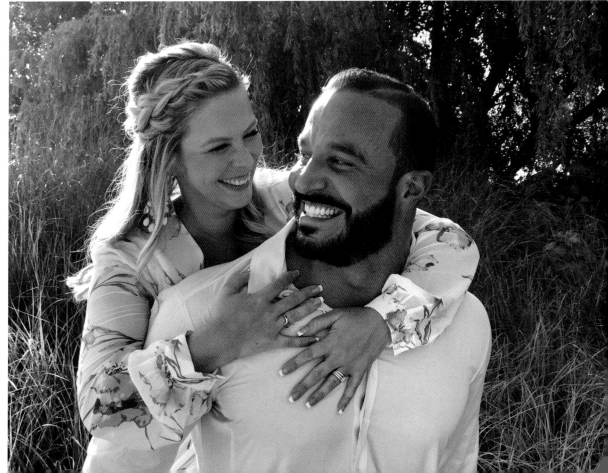

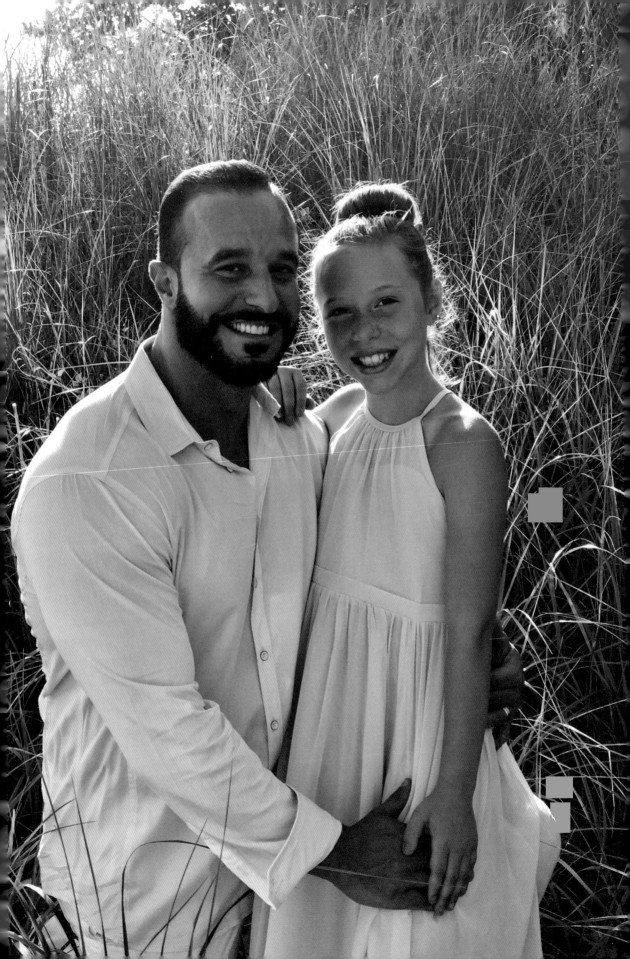

"Suggest small and simple changes in a pose to create a series of images with a narrative and a storytelling feel."

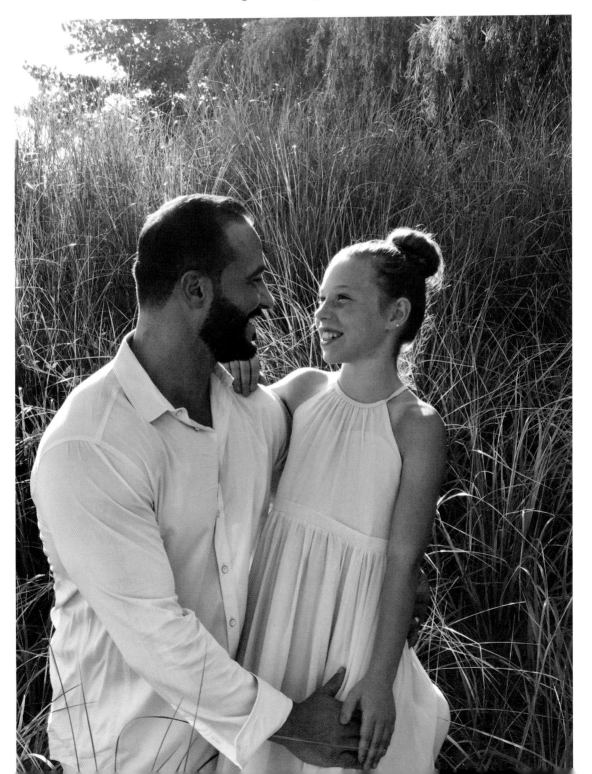

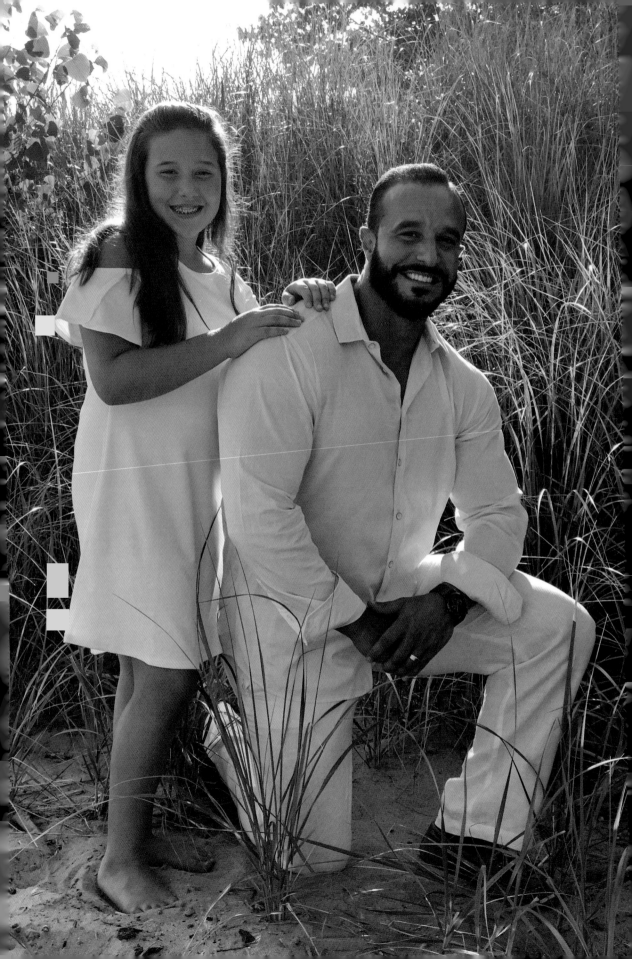

"Consider making a collage display of a collection of individually framed similar portraits for a cohesive look."

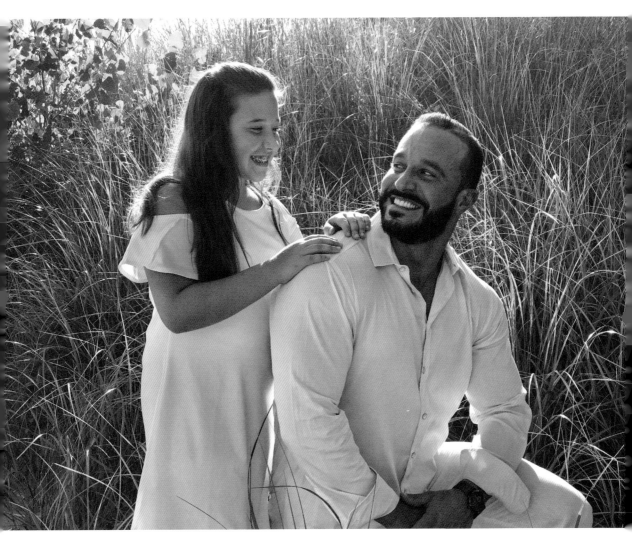

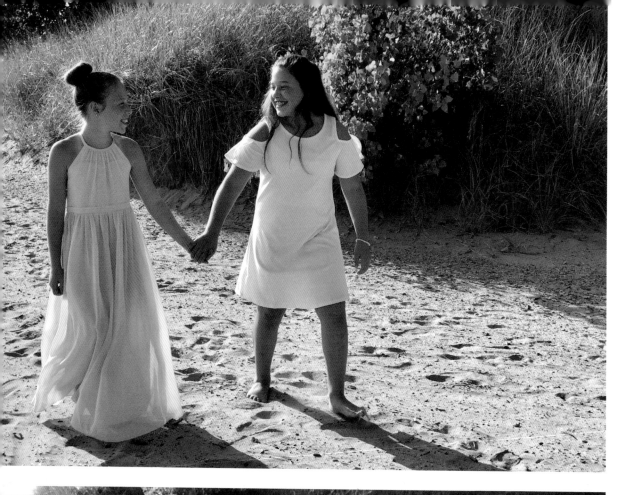

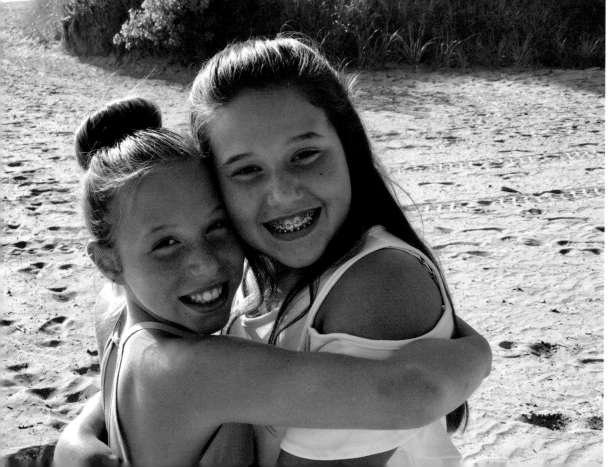

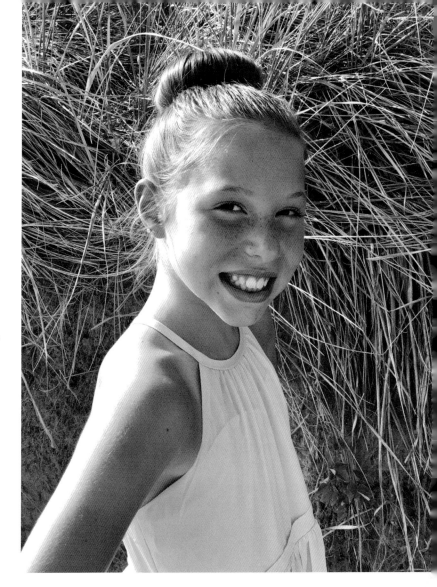

"Strengthen your photos by using the Rule of Thirds to design your portraits."

The Rule of Thirds

The Rule of Thirds is a theory photographers use to create visually compelling images. To use it, imagine a tic-tac-toe grid superimposed over your scene. The rule suggests that you should position a key element at a one-thirds vertical or horizontal line—or both. Also, the four points where the vertical and horizontal lines of the grid intersect are called "power points," and they are considered optimal areas in the photographic frame to position your subject.

Your phone allows you to activate a grid feature that you can use to create strong compositions. It's there for a reason. Use it. The only times that I break the Rule of Thirds is when I have lines that lead to the center of the image or create an image with a frame-inside-a-frame effect.

Simplify the Shot

I didn't have much of a background for this photo, so I used my iPhone's Portrait mode to blur the area behind the girl, while leaving her in focus. Sometimes less is more.

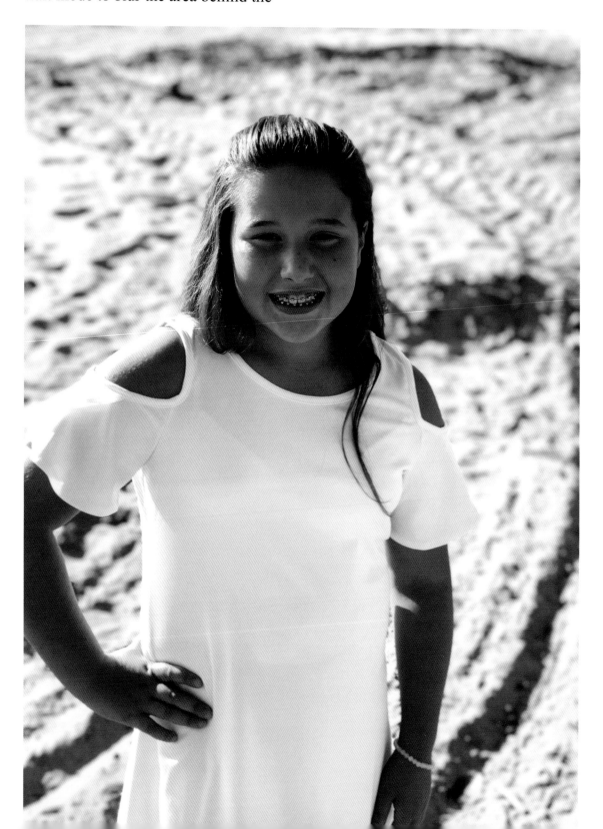

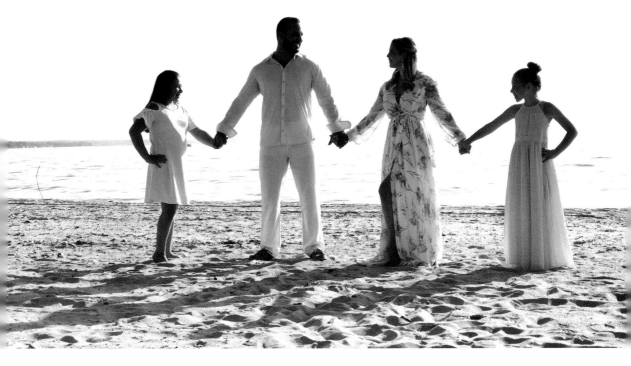

"Adding space between your subjects allows them to occupy more area in a landscape-format portrait without obscuring too much of the background."

Four Looks

Above and on the following page spread, you'll see four photos that feature the same pose, with each one made in a different lighting condition.

For the first image, the subjects were backlit and the background was bright. This resulted in more of a silhouette style of image.

For the second image, the sun was at camera right, giving the group a Rembrandt style of lighting.

Helpful hint: When I want my subjects to look at the sun, I give everyone a point of interest that's away from the sun. I have them close their eyes and open them on the count of three. As soon as I say "three," I will snap a

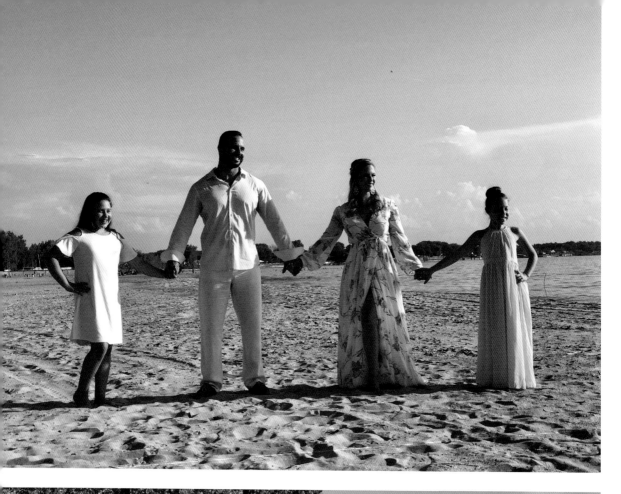
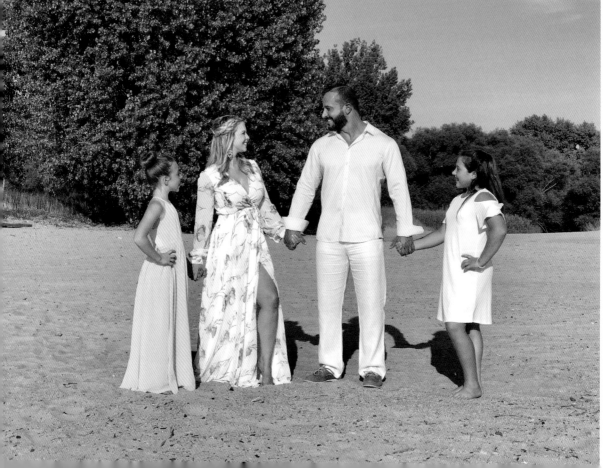

couple of photos in Burst mode by holding the shutter button down. I keep the best shot—the one in which everyone's eyes are open and no one is squinting.

For the third photo, the sun was completely behind the camera. In my opinion, this is the least flattering kind of light. It doesn't give the portrait any depth or interest.

The final image shows my favorite kind of light. The sun was slightly behind the subjects, and the sand reflected light onto the family's faces.

Always scan the scene to check for distracting elements. In the final image in this series, I was careful to position my subjects in such a way that the windmills in the background did not appear to protrude from anyone's head.

"Scan the background to look for distracting elements or things that may appear to protrude from your subject's head. Recompose the shot when necessary."

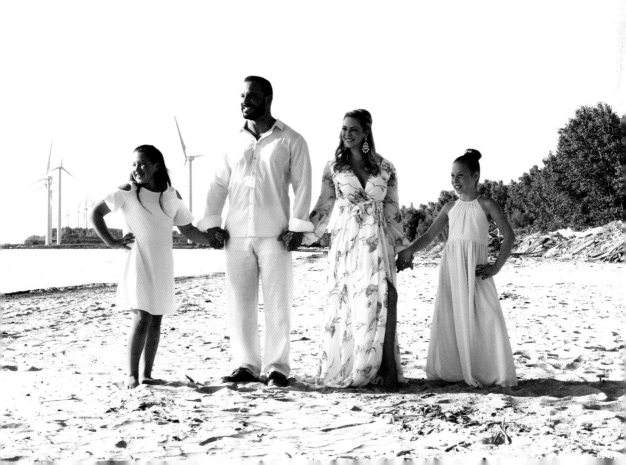

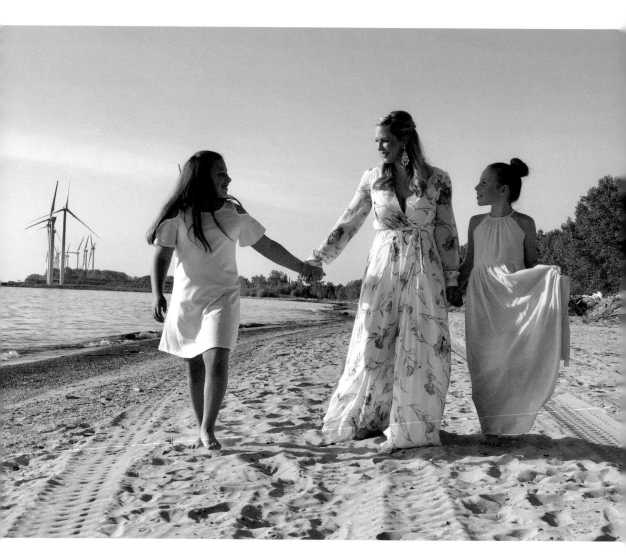

Bold & Bright or Soft & Subtle?

The images on this page spread look very different from one another. One is bold and bright, the other is soft and subtle, with a pastel coloration. Both styles can be done in-camera: it mostly depends on the direction of the light, your exposure, and the background you are working with. If the sun is slightly behind your subjects and you are shooting against a darker background, your images will have more contrast, which will give you a bold-and-bright look. When you have a bright background and you slide the exposure up so that your subjects are visible, you'll get a softer look, with a high-key or watercolor feel.

I like to have my subjects wear pastel colors and loose, flowing clothing when photographing them alone or in groups on the beach. I feel that it creates a bright and airy look in the images.

"Reassure your subjects that they are doing a great job and look wonderful. This will help put them at ease."

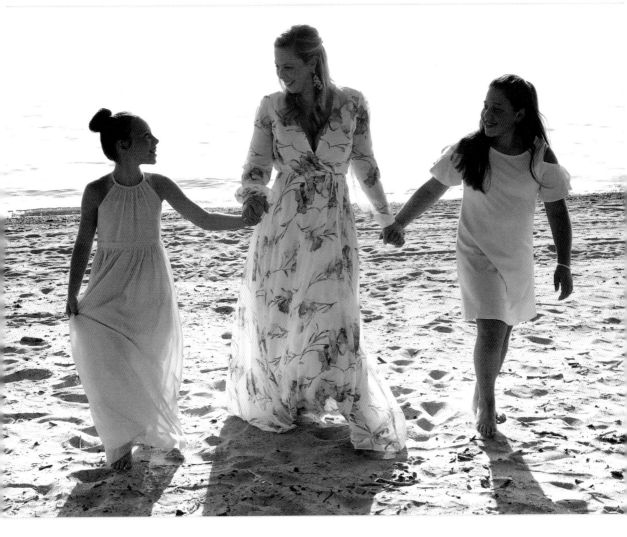

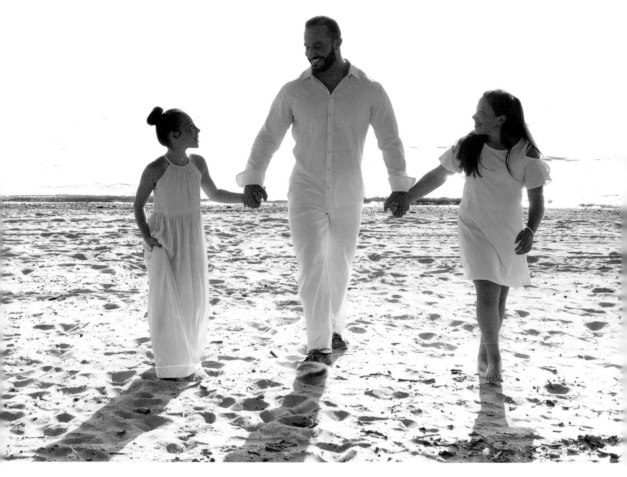

Playing with Long Shadows

Shadows can be used to add graphic interest within the frame. You can use long shadows as leading lines or silhouette forms on the ground or nearby walls. Using shadows can pack a powerful punch in your portraits.

"Introduce shadows to add graphic interest in the frame."

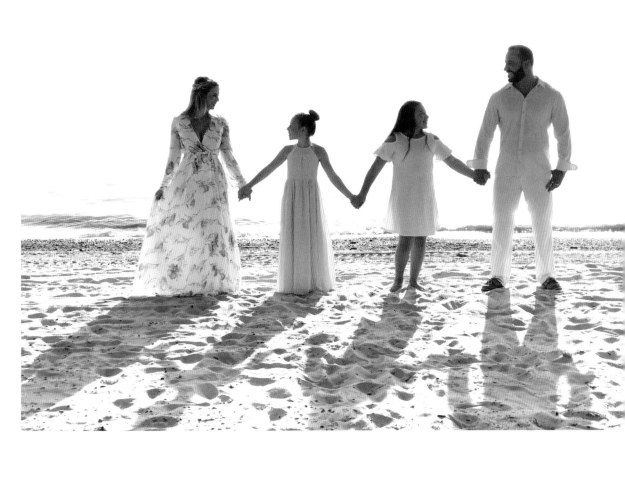

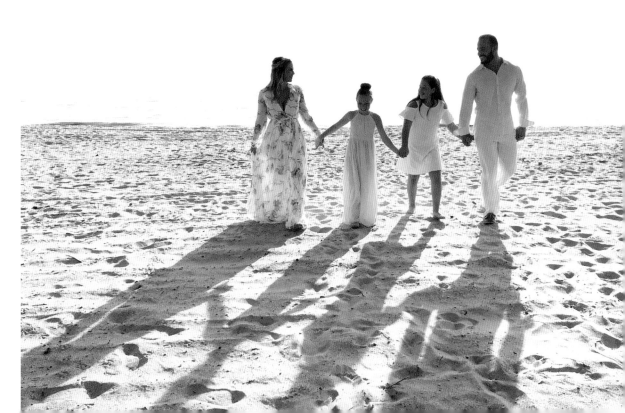

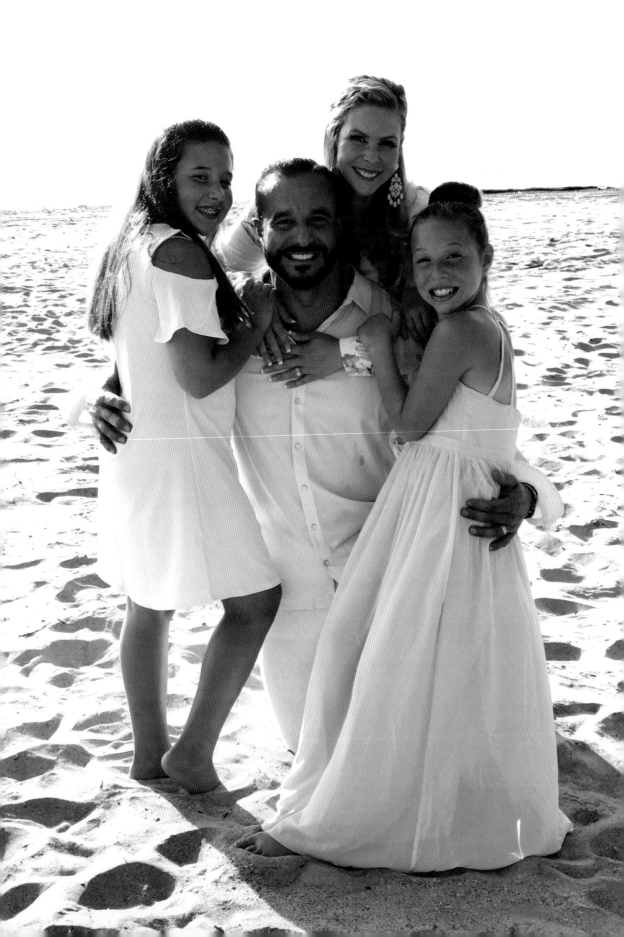

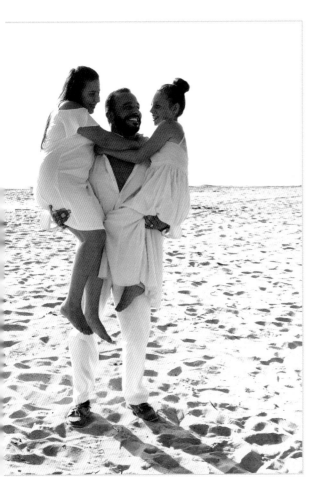 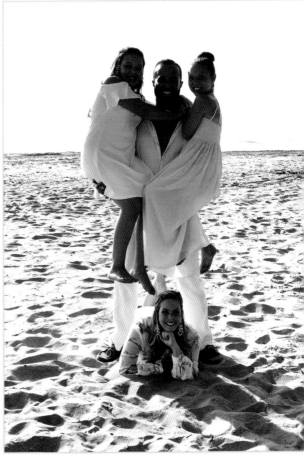

> **"Most people shoot from eye level. Try a low or high angle for a more artful and memorable portrait."**

Perspective

Most photographers shoot from eye level, but don't be afraid to get down low or to shoot from a higher perspective. If people are posed lower on the ground (e.g., sitting, squatting, or kneeling), or kids or pets are present in your group, be certain to get down to their level.

In the images above, I wanted the dad to be a larger-than-life figure as he held his two girls in the air. He did this pose on the day of his wedding, and I thought it would be fun to re-create it here. I crouched down to shoot upward, making him look bigger in the frame. While I was shooting from a low angle, Mom hopped in for a fun shot!

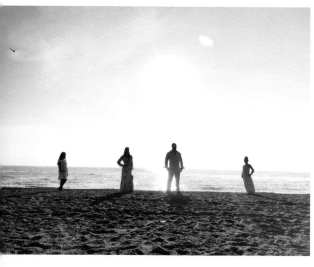 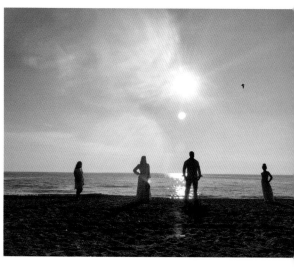

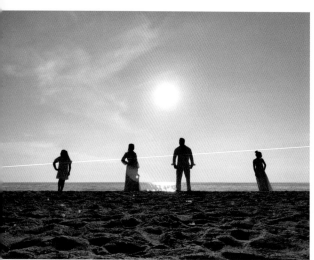 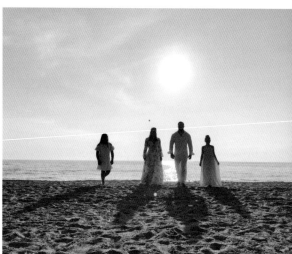

Throw Some Shade

Some professional photographers add specially made filters in front of their lenses to create color effects, reduce light, and even intensify blue skies and eliminate glare on reflective surfaces.

The next time you head out to photograph your family, try shooting through a pair of sunglasses—or multiple pairs with lenses that have different tints—to create some fun and unique looks.

I used multiple pairs of sunglasses for this series of images. It's always fun to experiment with different

kinds and brands of shades. Some will add color, and some will reduce the light used to create the image, giving you a dark and moody portrait. Some shades have a gradient lens that will darken the sky and leave the lower part of the scene light.

Once you find a sunglass-filter look you like, create a memorable image. In the image below, we have backlight, dramatic shadows, and the reflection of the sun off of the water for a slight lens flare. The family was having fun walking hand in hand, and their smiles were the icing on the cake. This is definitely a print-worthy portrait.

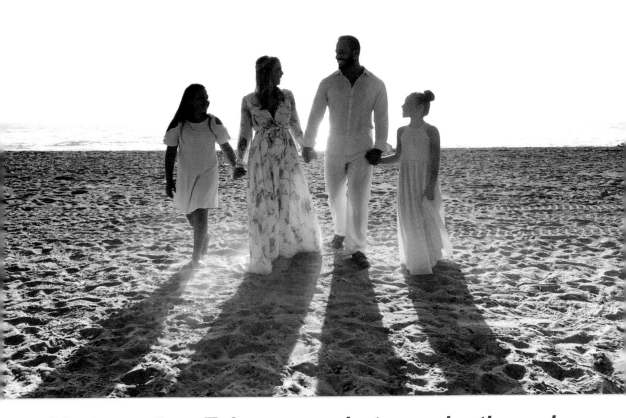

"Get creative. Take some photographs through the lens of your sunglasses to add an interesting tint, right in-camera."

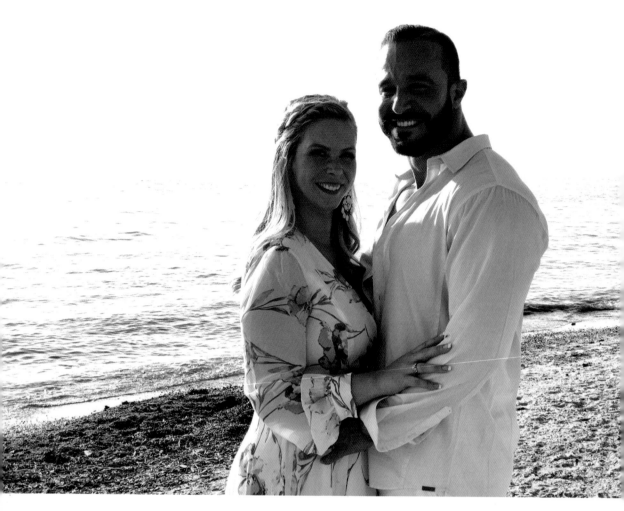

"Wedding and engagement photographs can be a source of inspiration when photographing a mom and dad together. Capitalize on the warmth, romance, friendship, and fun."

above. Setup photo for above image.

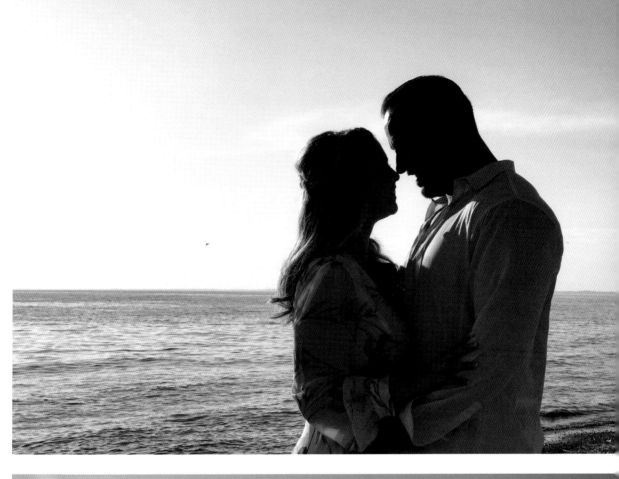

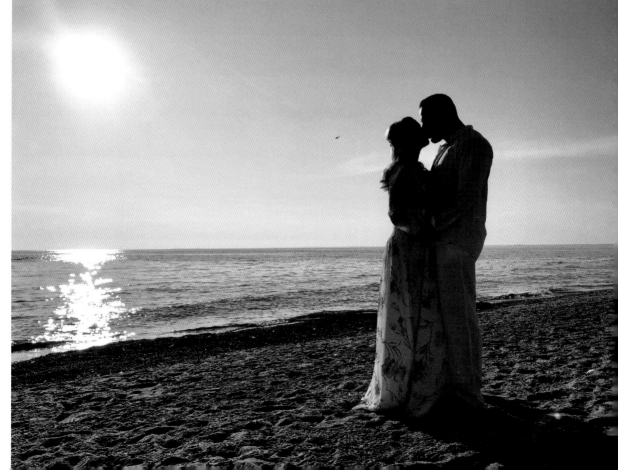

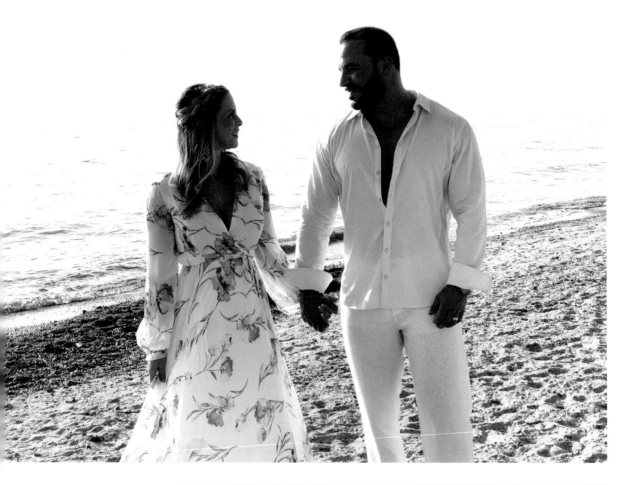

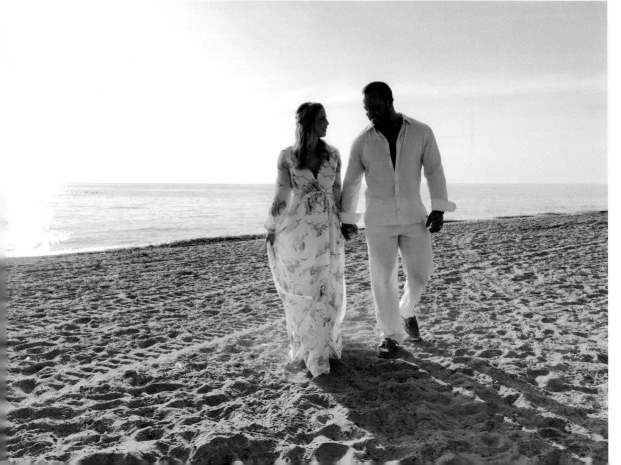

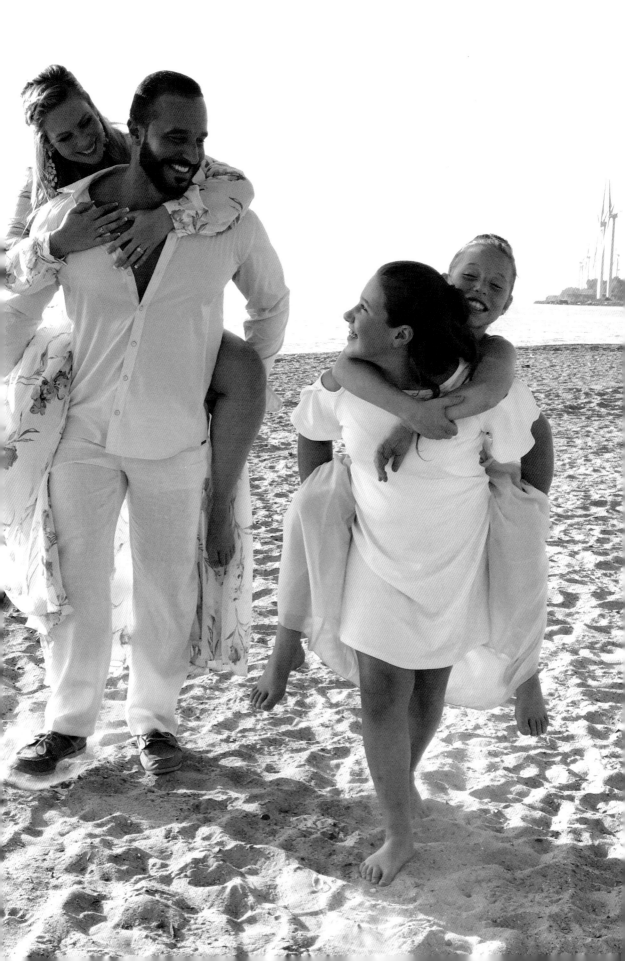

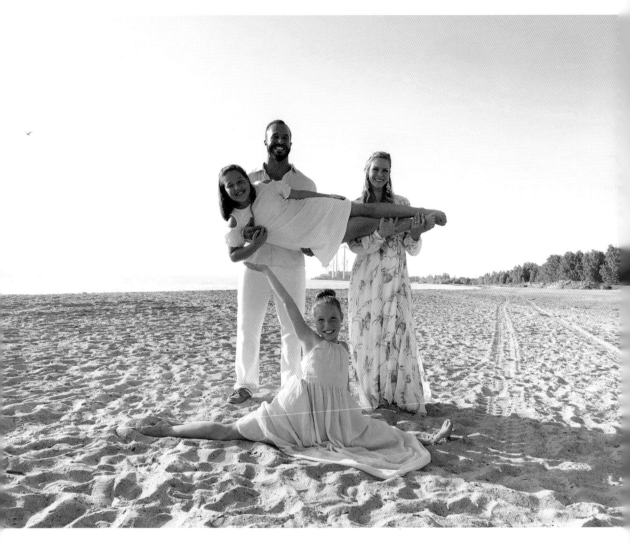

"Have fun with your photography. Think outside the box when posing your subjects."

In the City

above. **Setup photo for below image.**

The Wow Factor

When working with architecture or buildings that include columns, a formal outfit often looks best. We had mentioned to our clients that they should dress for their session as they would for a black-tie event. The clothing helped to guide the approach we took to posing our subjects during this session. After all, formal outfits call for formal poses.

The light was bright but overcast during this noontime session. This gave me the freedom to pose our

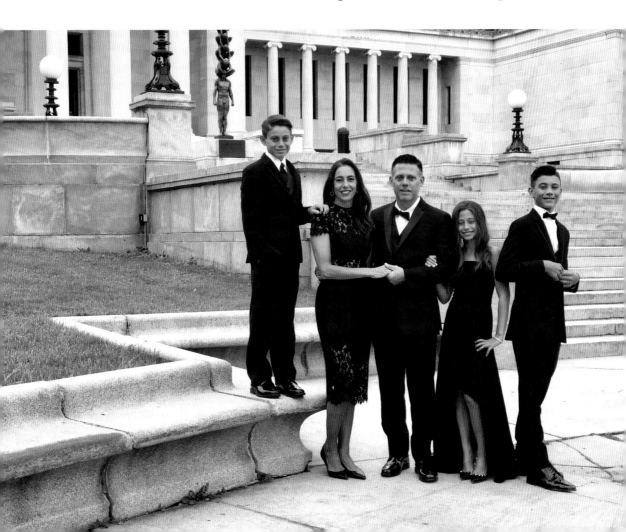

clients pretty much anywhere because the light was beautiful and consistent from one spot to the next. I did selectively play with the exposure to enhance the mood of the portraits, though. For the photos with a more serious feel, I reduced the exposure a little to achieve a slightly darker, more dramatic look. I turned the exposure up a bit for the pillar portraits.

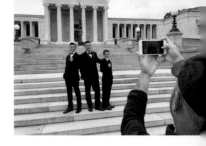

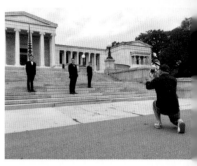

top. Setup photo for image below.

bottom. Setup photo fo top image on following page.

"Use the Grid feature to ensure that any architectural lines in the frame are straight."

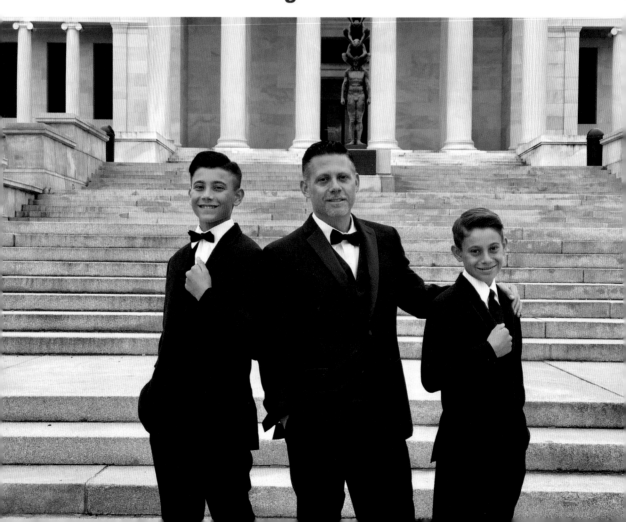

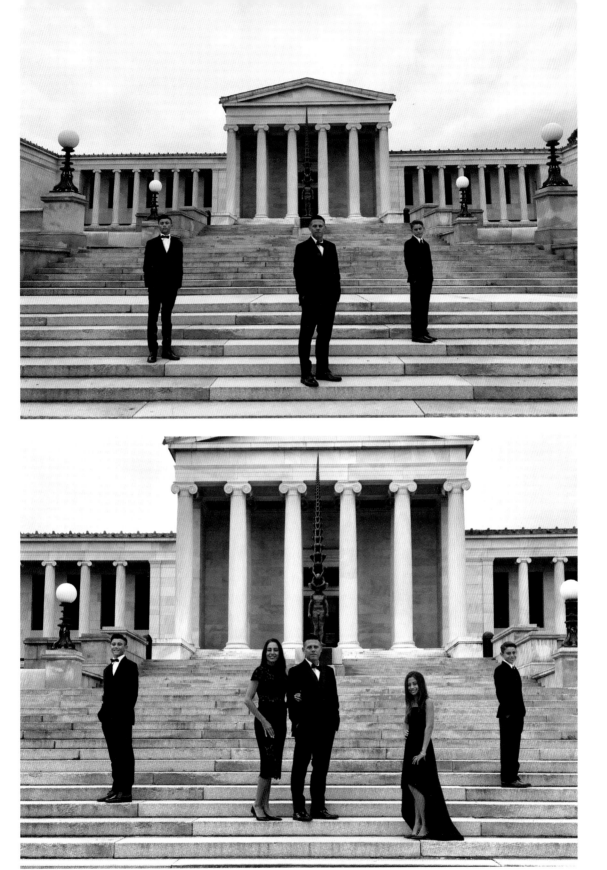

"Dark clothing and a predominantly light location can make for dramatic black & white images."

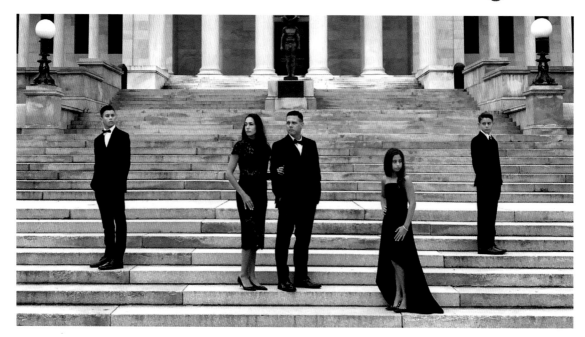

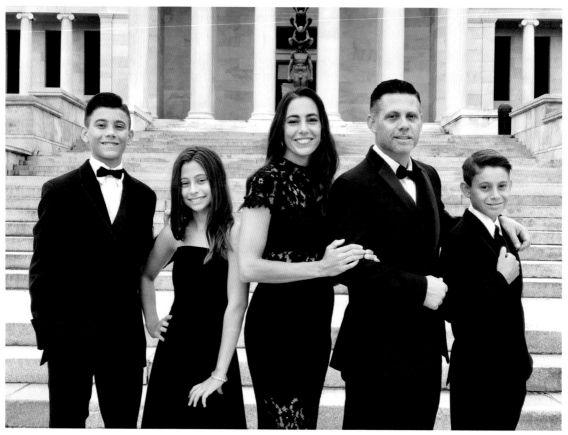

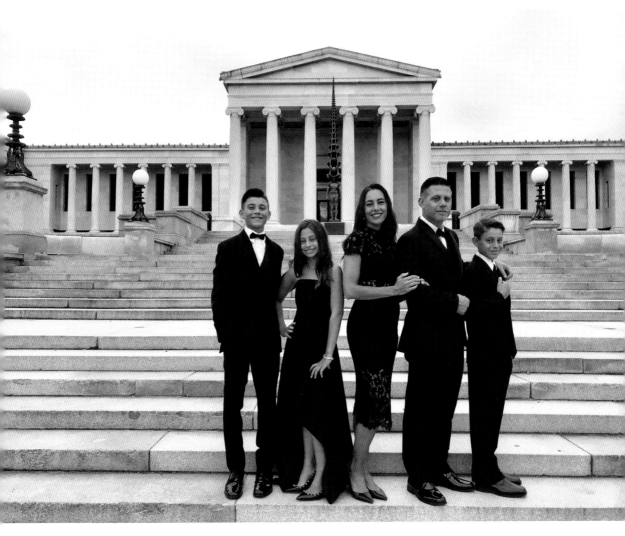

right. Setup photo for above image.

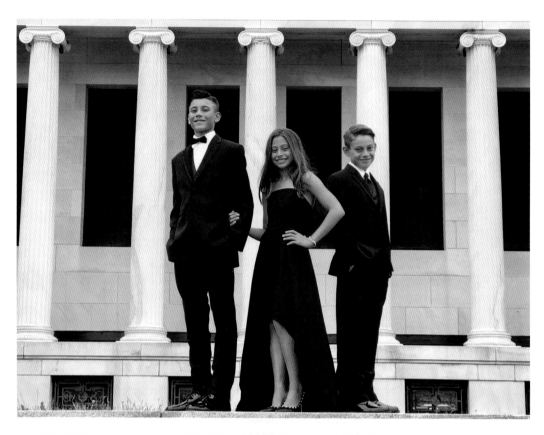

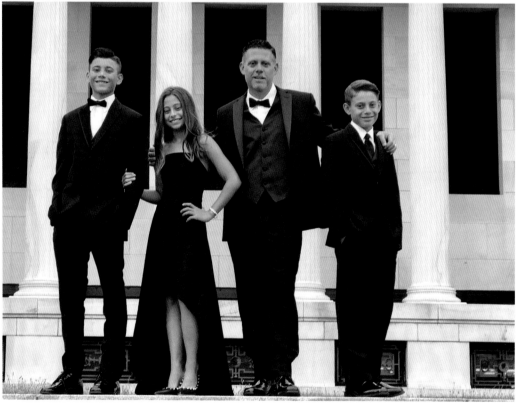

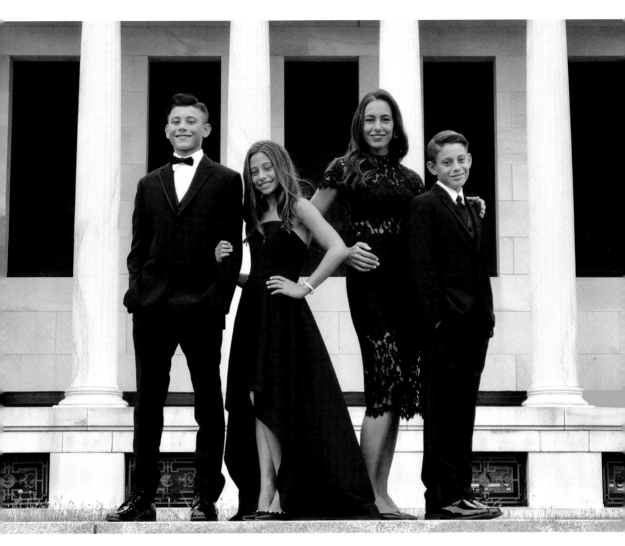

right. **Setup photo for above image.**

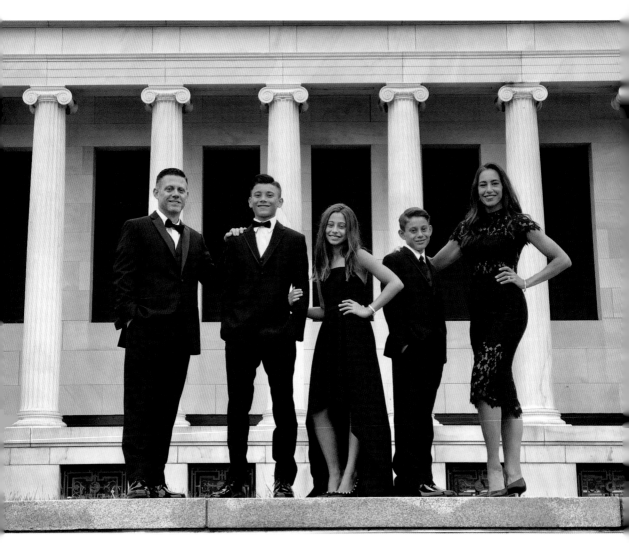

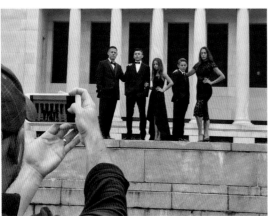

left. **Setup shot for image at top of page.**

right. **Setup shot for image on following page.**

"Experiment with subject placement. Create some poses in which the family is huddled together, and others with lots of space between them for more variety and greater artistic impact."

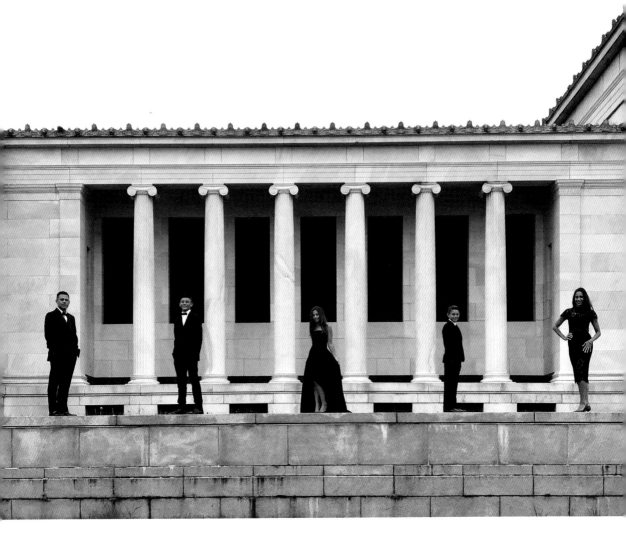

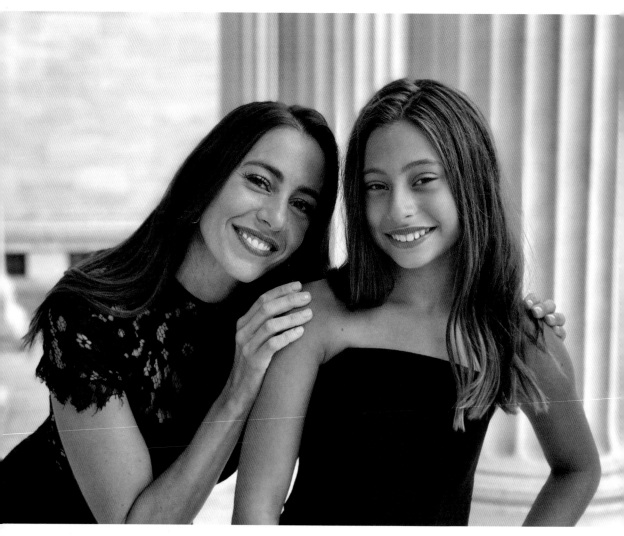

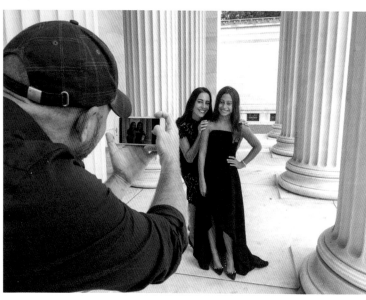

left. Setup photo for above image.

"For a flattering look, avoid posing your subjects with their bodies square to the camera. A slight angle will provide better, more polished results."

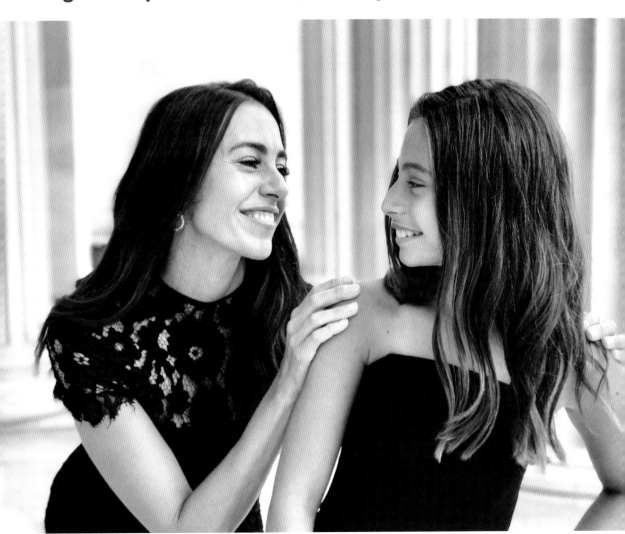

"Have your subjects drop one shoulder slightly lower than the other for a more dynamic pose."

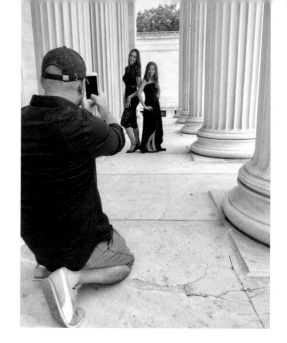

right. Setup photo for image on the following page.

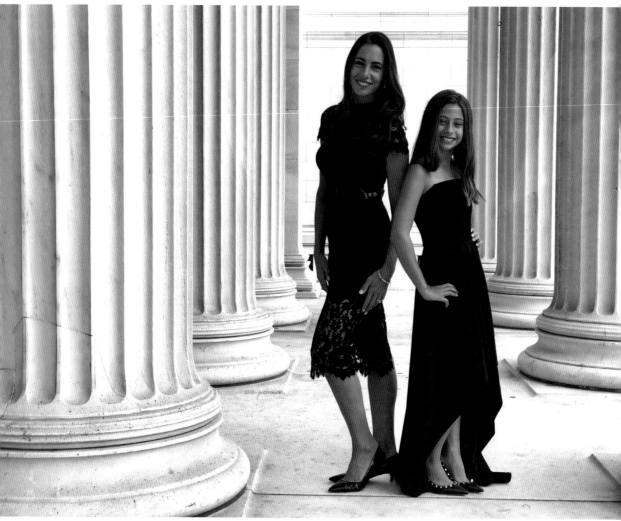

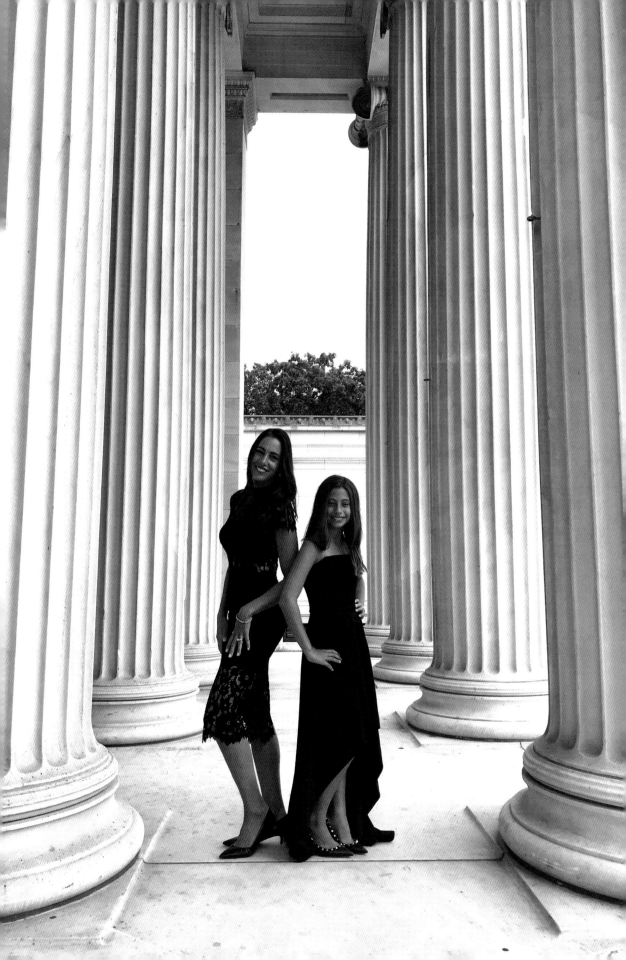

"Aim to achieve a triangular position of the heads when photographing three or more subjects."

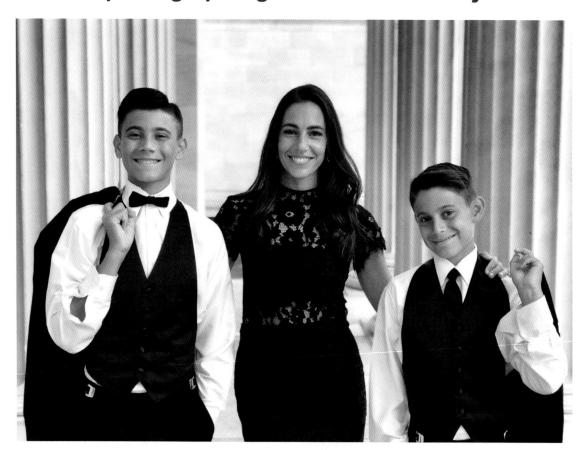

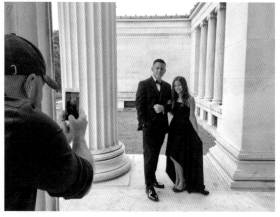

left. Setup shot for top image, which was converted to black & white after the shoot.

right. Setup shot for image on the following page.

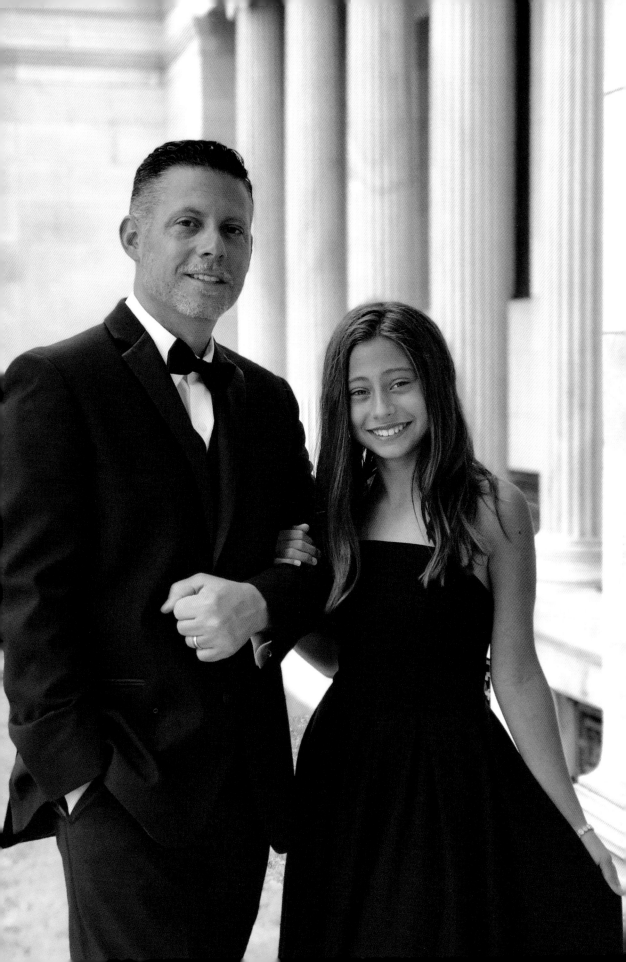

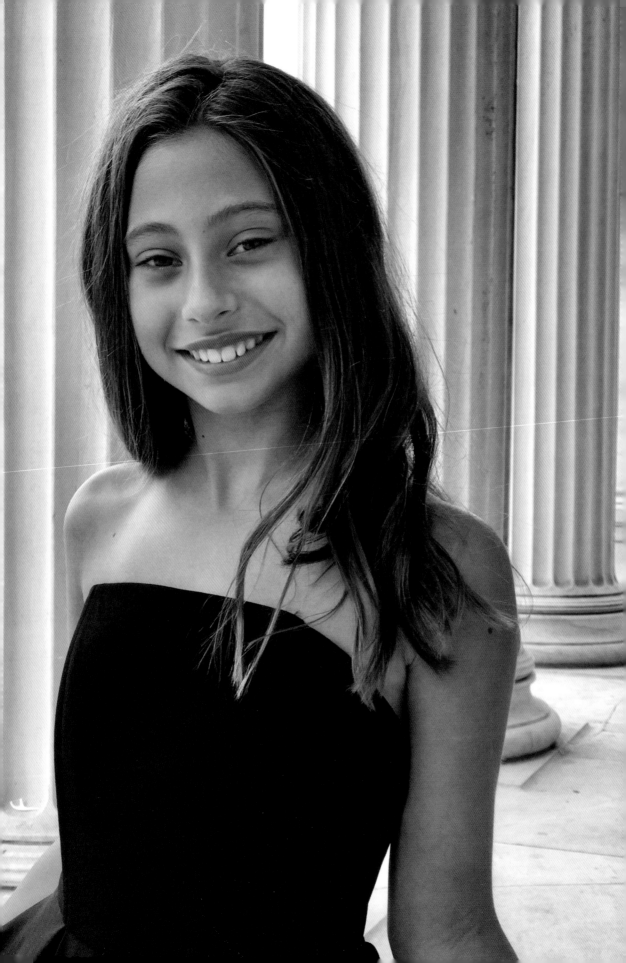

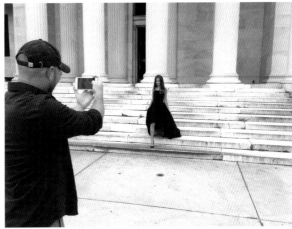

left. Setup photo for image on the previous page.

right. Setup photo for image below.

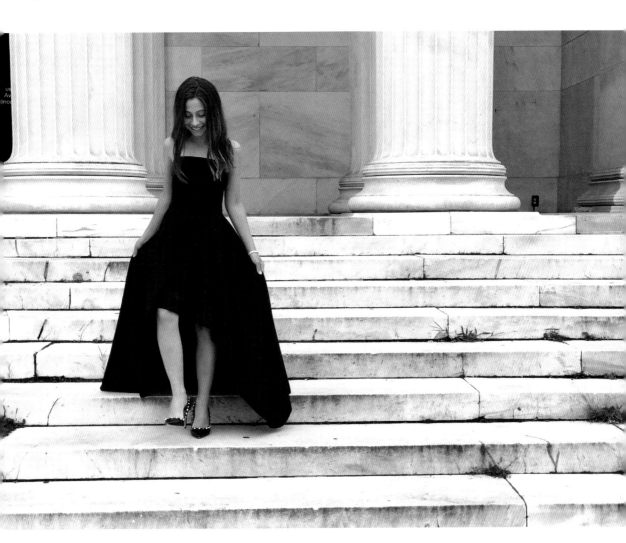

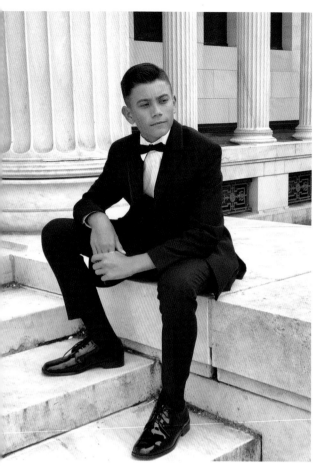

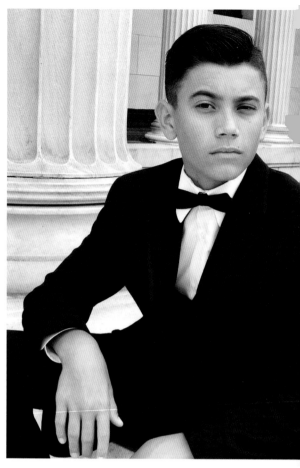

"Avoid rigid poses. Have the subject bend an elbow or knee, or adjust their shoulders so one is a little bit lower than the other."

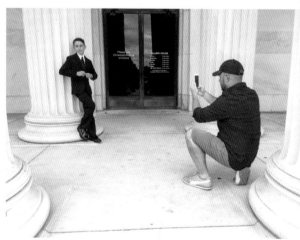

above. Setup photo for the image on the following page.

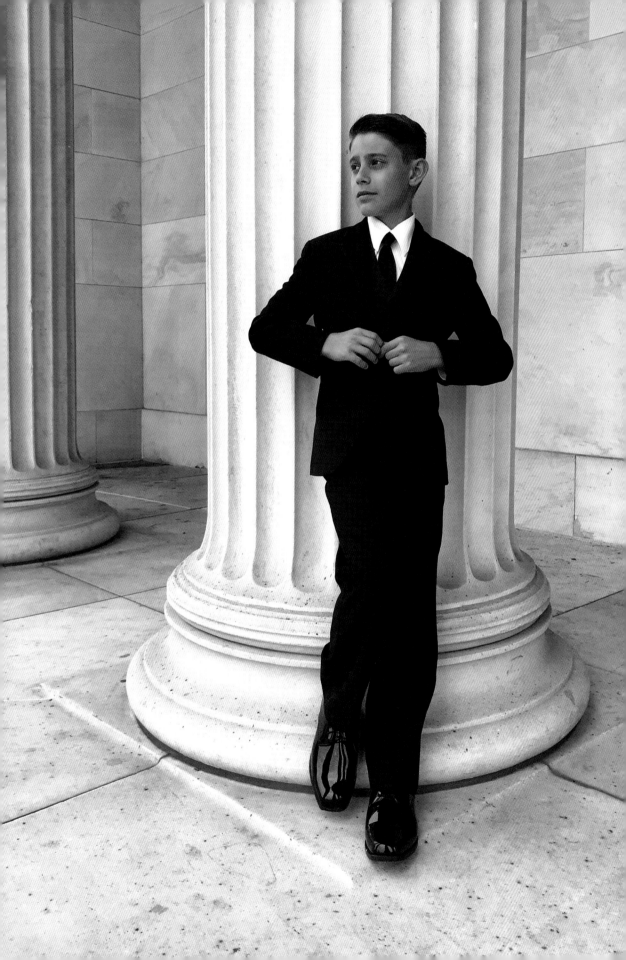

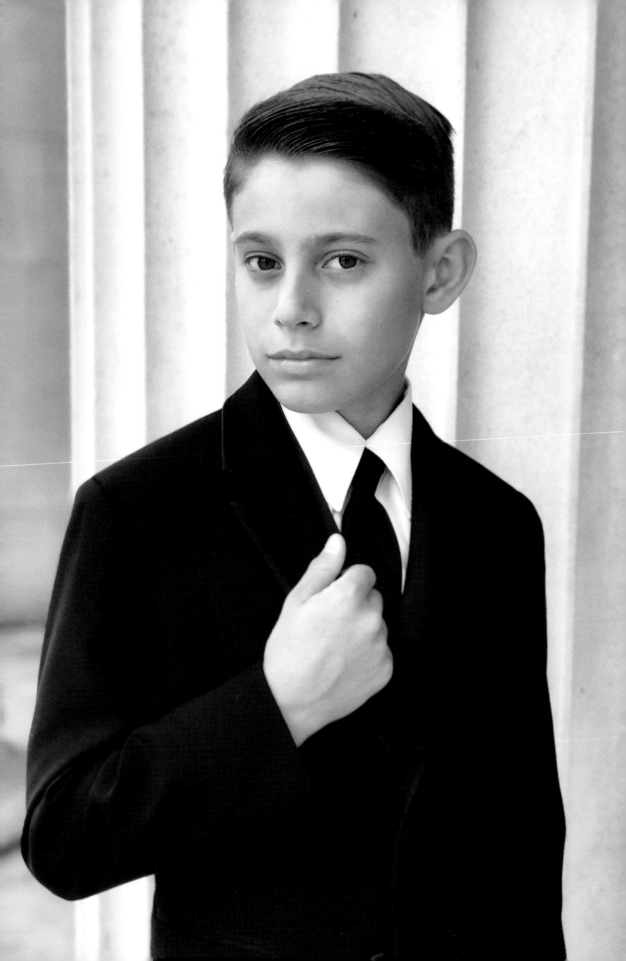

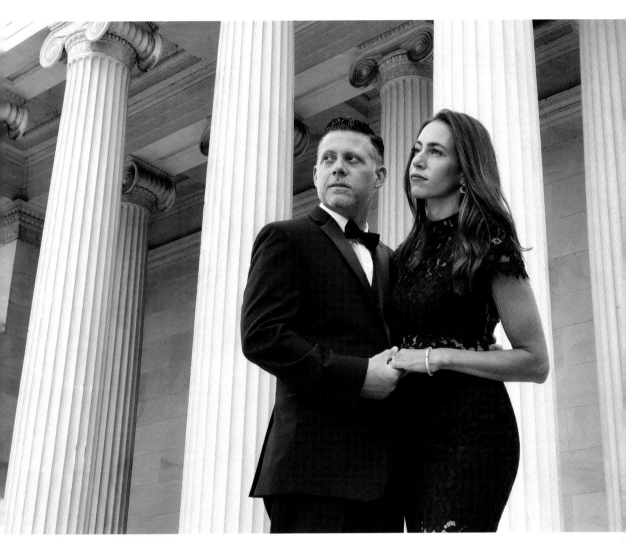

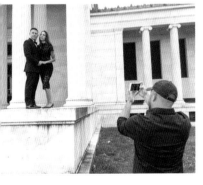

above. **Setup photo for top image.**

"Put a couple on a pedestal. Shoot from a low angle to create a dramatic look that differs from the point of view captured by most photographers."

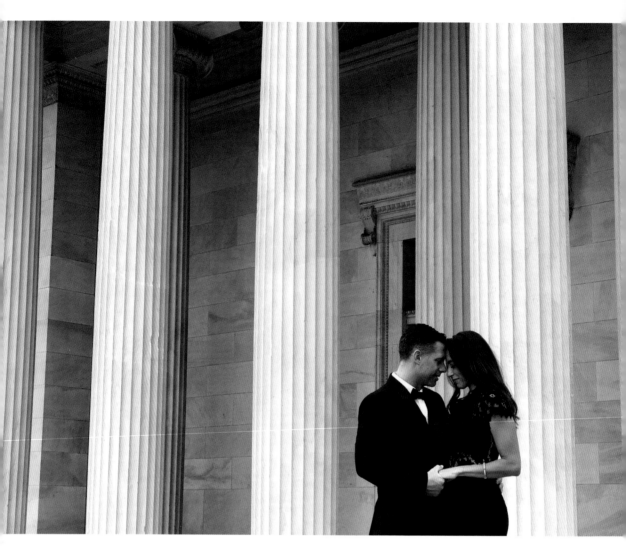

"The viewer's eye is drawn to an area of high contrast. Use an approach like this one to make your subjects the stars of the photo—even in the midst of a dramatic background."

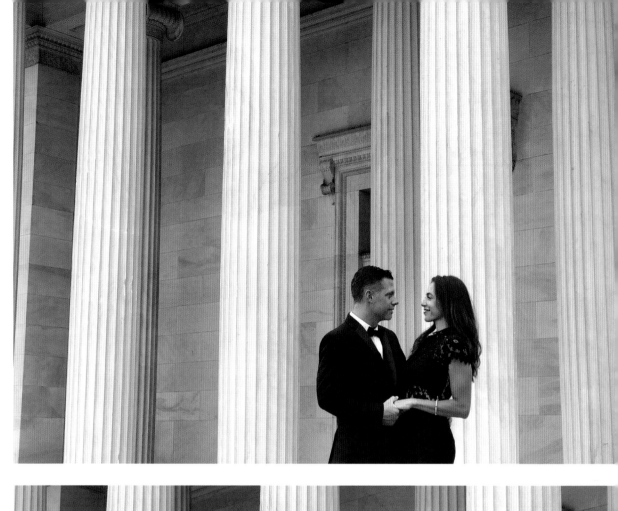

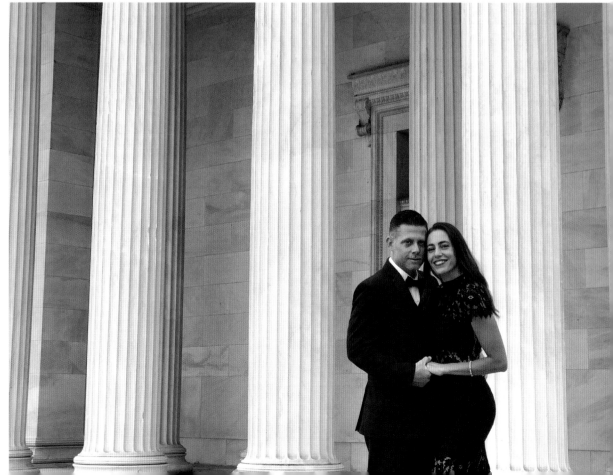

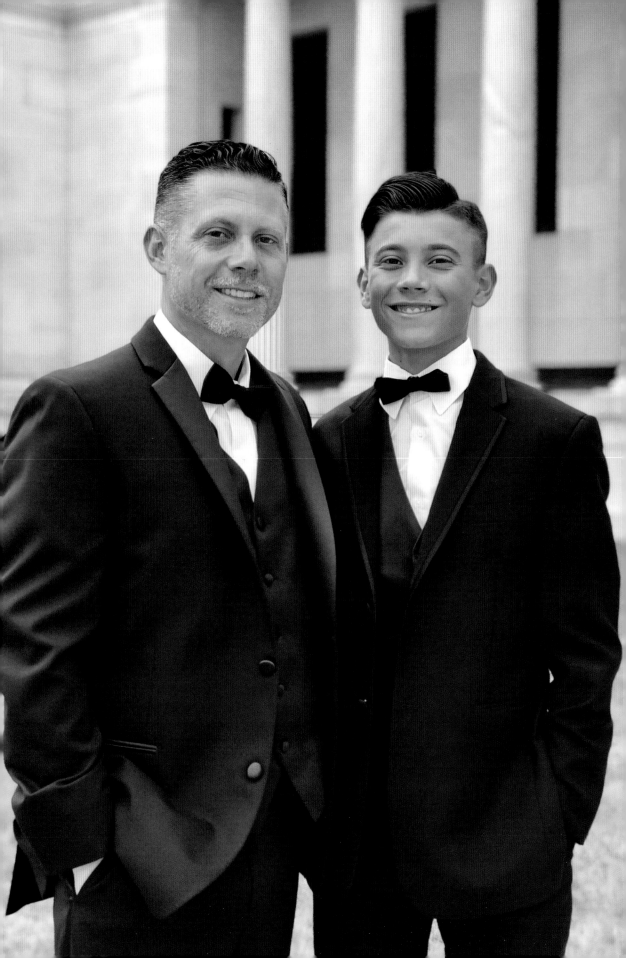

"After taking a shot, carefuly review it. Zoom in to make sure everything is in focus and no one's eyes are closed."

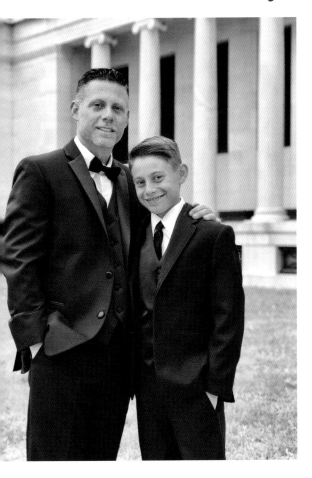

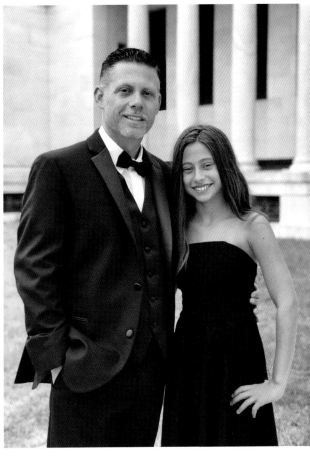

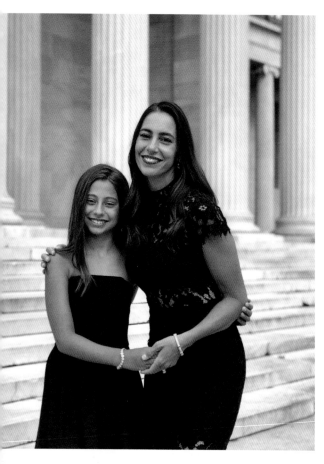

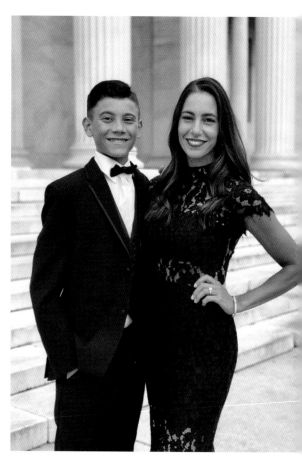

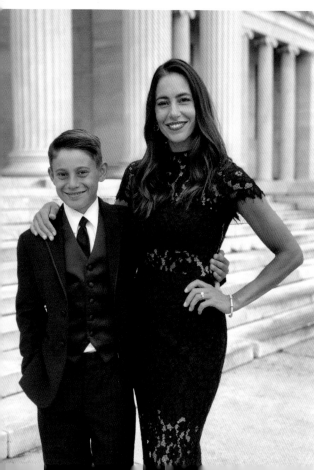

"Print and display your best family images. Don't let the files sit idly on your camera."

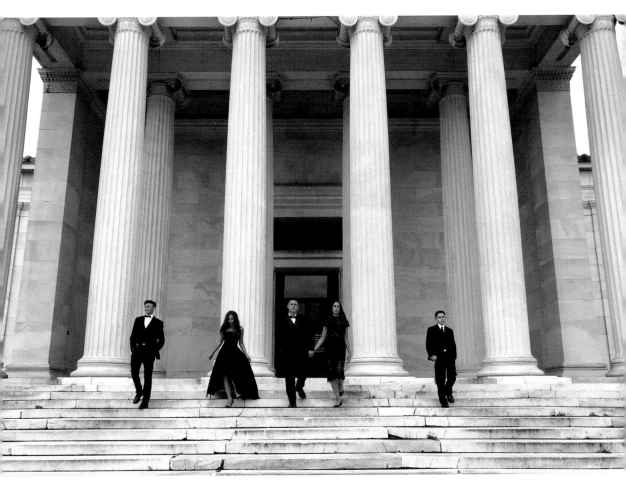

After the Session

Editing Your Images

For this book, I kept editing to a bare minimum because I wanted to show you the images you can take with your iPhone, and how great they can look without any editing. Android and Google Pixel users can create incredible mobile phone family photographs when they learn the basics of photography, too.

When I do edit my images, I often use the Auto edit button. I always like to see what my iPhone will do to the images. Sometimes it's a dramatic change, and sometimes there's no change at all, but it's always a fun

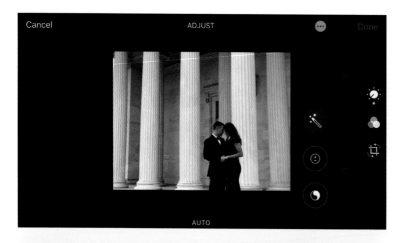

top and bottom right. **The iPhone's Auto edit feature is activated by clicking on the Magic Wand icon.**

"Aim to create perfect images in-camera, so any editing tweaks are minor and optional."

top. Sharpness adjustment.

center. Definition adjustment.

bottom. Vignette added.

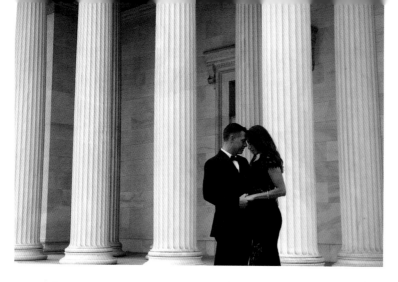

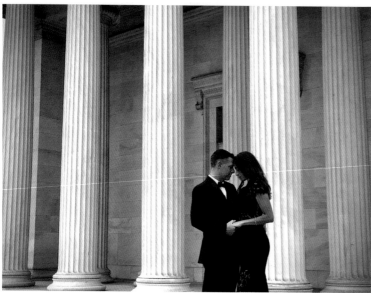

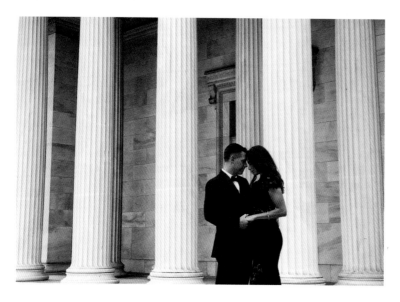

top. The original, un-edited image.

center. Here is the image with the iPhone's native Camera app edits made.

bottom. For this version of the photo, I used Snapseed to introduce a film look.

button to hit. Once that's set, I adjust from there. I often reduce the Vibrance, increase the sharpness, and increase the definition. Sometimes, I will add a subtle vignette.

There are a ton of third party apps on the market. Many of them are free. Some are free, with additional purchases available inside the app. I often use Snapseed. For this image, I added a film look that decreased a little bit of contrast and added some grain. I also cropped the image just a bit off the top. Try some apps out and develop your own style.

top. **The iPhone's Noir filter.**

bottom. **A black & white treatment with a touch of color brought back in.**

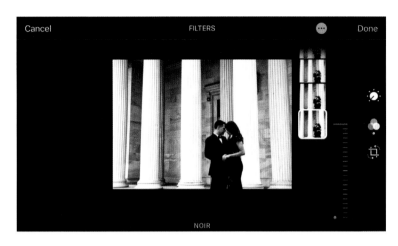

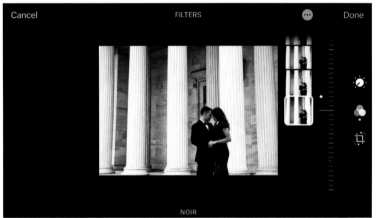

Convert Your Images to Black & White

Black & white photos are classic, and when it comes to editing, you'll find that you want to experiment with some black & white filters for your images. Of course, I shoot with an iPhone. The native Camera app offers a selection on black & white filters through the Edit menu. Click on Edit, then select the Filters icon at the bottom of the screen. When you swipe to the left, you will see a Mono, Silvertone, and Noir option. I often lean toward Noir. You can use the slider to decrease the desaturation effect if you want to leave a little bit of color in your image.

Snapseed also offers a variety of black & white filters that iPhone photographers and Android users will appreciate.

Back Up Your Files

Most people take for granted that their photos will remain safe on their phone's camera roll, but that's certainly not always the case. Do yourself a favor and be sure to periodically back up your images. Some day, you'll be glad you did.

Your approach to backing your images up to your computer or to a

"Do yourself a favor and be sure to periodically back up your images."

> ## *"You can print them at home if you have a high-quality printer, but the results will be much nicer if you have your prints produced by a professional lab."*

Cloud storage platform will depend on the mobile device you are using and, if you are backing up to a computer, the platform you use (Mac or PC). Seek out a simple tutorial to learn how to transfer your images from your phone, based on make and model, to your computer. Alternatively, or additionally, you may want to upload your files to Amazon Cloud or Google Drive. Again, the steps for doing so will vary based on your personal equipment.

Printing Your Images

Once you have backed up, and possibly refined, your images, you'll probably want to have some printed, too. You can print them at home if you have a high-quality printer, but the results will be much nicer if you have your prints produced by a professional lab.

Ideally, any image you print will have a resolution of at least 300dpi. You may be able to get away with a little less if you are ordering canvas prints or printing onto textured paper.

Look to your subjects and locations for clues about the printing medium that will work best. Families photographed in formal clothing may appreciate metal prints; those photographed in a casual or rustic setting might favor wood prints. Framing and matting should suit the overall style and mood of the images, too.

What's Next?

Once you master mobile photography, you will be ready for a DSLR or mirrorless camera body with interchangeable lenses. Have fun, and enjoy the journey!

Index

AmherstMedia.com

- *New books every month*
- *Books on all photography subjects and specialties*
- *Learn from leading experts in every field*
- *Buy with Amazon (amazon.com), Barnes & Noble (barnesandnoble.com), and Indiebound (indiebound.com)*
- *Follow us on social media at: facebook.com/AmherstMediaInc, twitter.com/AmherstMedia, or www.instagram.com/amherstmediaphotobooks*

Create Pro Quality Images with Our Phone Photography for Everybody Series

iPhone Photography for Everybody

Black & White Landscape Techniques

Gary Wagner delves into the art of creating breathtaking iPhone black & white landscape photos of seascapes, trees, beaches, and more. $29.95 list, 7x10, 128p, 180 color images, ISBN 978-1-68203-432-3.

Phone Photography for Everybody

Still Life Techniques

Beth Alesse provides creative strategies for photographing found objects, collectibles, natural subjects, and more with your phone. $29.95 list, 7x10, 128p, 160 color images, ISBN 978-1-68203-444-6.

iPhone Photography for Everybody

Artistic Techniques

Michael Fagans shows you how to expertly use your iPhone to capture the people, places, and meaningful things that color your world. $29.95 list, 7x10, 128p, 180 color images, ISBN 978-1-68203-432-3.

Phone Photography for Everybody

iPhone App Techniques—Before & After

Paul J. Toussaint shows you how to transform your iPhone photos into fine art using an array of free and low-cost apps. $29.95 list, 7x10, 128p, 160 color images, ISBN 978-1-68203-451-4.

iPhone Photography for Everybody

Landscape Techniques

Barbara A. Lynch-Johnt provides all of the skills you need to master landscape photography with any iPhone. *$29.95 list, 7x10, 128p, 160 color images, ISBN 978-1-68203-440-8.*

Phone Photography for Everybody

Creative Techniques

Beth Alesse teaches you how to combine expert phone shooting techniques, artistic vision, and apps for next-level images. $29.95 list, 7x10, 128p, 160 color images, ISBN 978-1-68203-449-1.